THE
DOGS OF CUBA

by Emmy Park

SCHIFFER PUBLISHING

4880 Lower Valley Road • Atglen, PA 19310

FOREWORD

By Hatzel Vela | Cuba Correspondent | Journalist

When it was announced the United States and Cuba were on a path to renewing an old friendship, part of the approach to improve relations was to allow more Americans to travel to the once-forbidden island. It is that interaction that would create a connection between the people of two countries who for decades played political foes on the world stage. It presented an opportunity that would ultimately lift the decades-old veil of secrecy and allow Cubans to experience the American spirit firsthand, but was also a chance for Americans to immerse themselves in Cuban culture, art, music, food, and history.

Since then, Emmy Park has done all that and more! This talented photographer first arrived in Havana in 2015, first documenting the Cuban skateboarding scene. But she took it a step further. Park knew her lens could bring the world an often-unnoticed side of Cuba. Her work has culminated in an unforgettable and heartwarming tour of Cuba's different provinces and its *mascotas*. Whether you love cats or dogs, this book shows you the Caribbean island through the eyes of its most vulnerable creatures, which often stand quietly in the background of Cuba's complex past and present. Park delivers a compilation of jaw-dropping photographs where you can palpably feel the realities that remind us that while humans struggle, it is their furry loved ones that take the brunt of the surrounding human condition and its reality.

After you're done flipping through its pages, this book is bound to become a classic for any animal lover who may also want to escape to a country once hardly accessible to Americans. It will touch your heart!

INTRODUCTION
By Emmy Park

I traveled to Cuba for the first time in April of 2015. I knew very little of the country, except from what I had read and seen in films. I immediately noticed dogs everywhere, on each street corner. I learned there are no laws for the protection of domestic animals in Cuba, thus leading to the abuse and abandonment of dogs.

In this book, I welcome you to journey along with me from eastern to western Cuba. While traveling through various cities and towns, and ultimately arriving on Isla de la Juventud, I will share my exploration into the lives of Cuba's dogs and their human caregivers. You may sometimes see a dog wearing *la tira roja* (the red ribbon), which represents the Yoruba Orisha Shango (God of Thunder) and is believed to be a protection against evil. In Habana Vieja, you will see dogs with an ID tag—a program originally created by an animal protector to prevent dogs from the hands of Zoonosis, a government entity that belongs to the Ministry of Public Health. Zoonosis collects stray dogs, and after seventy-two hours of starvation (owners can claim their dog during this period), they are fed food laced with strychnine and endure a slow, painful, and inhumane death. During Cuba's winter months, you may also see dogs in T-shirts. Despite their own struggles and limited resources, the people of Cuba still think about keeping their dogs warm.

Through social media, I connected with animal rescue organizations in Cuba and decided to use my photography to raise awareness for the plight of the dogs in Cuba. With the help of followers on social media and local supporters, every time I travel to Cuba I bring as many medical supplies, collars, leashes, toys, and dog food as I can carry to donate to the local animal rescue volunteers. My hope is that after seeing these images you will feel inspired to join this movement in helping the dogs of Cuba.

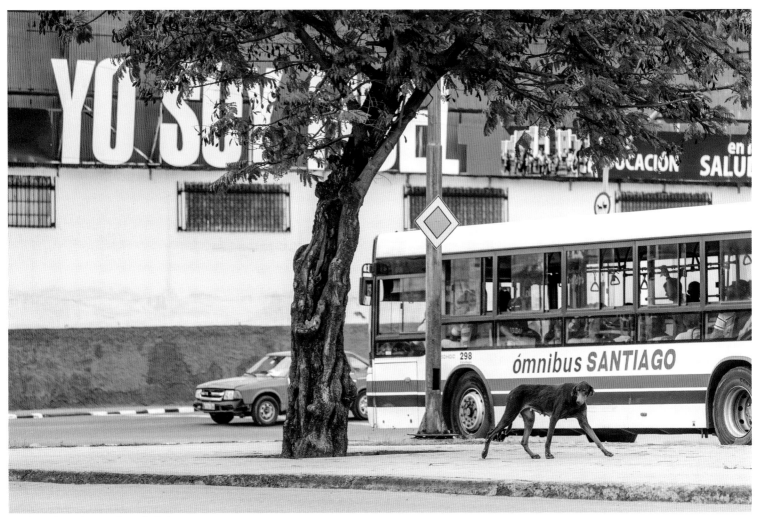

Santiago de Cuba, Santiago de Cuba

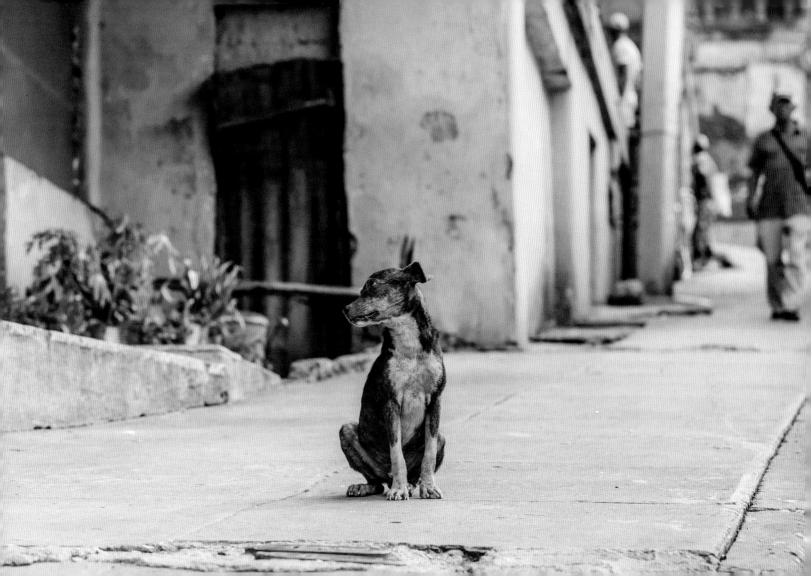

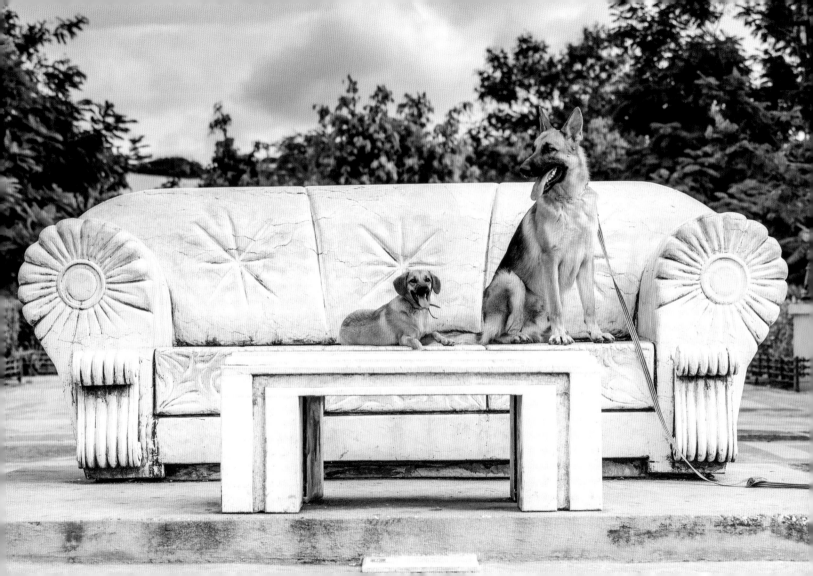

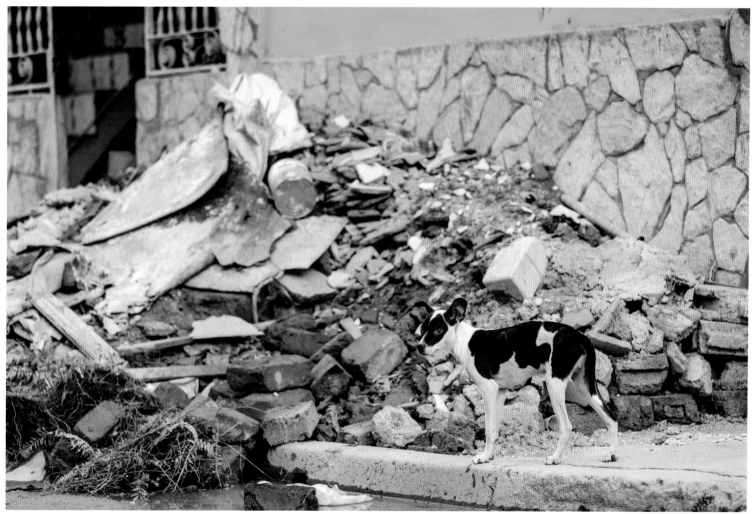

Gerry y Dom, Living Room by José M. Díaz, Santiago de Cuba, Santiago de Cuba

Santiago de Cuba, Santiago de Cuba

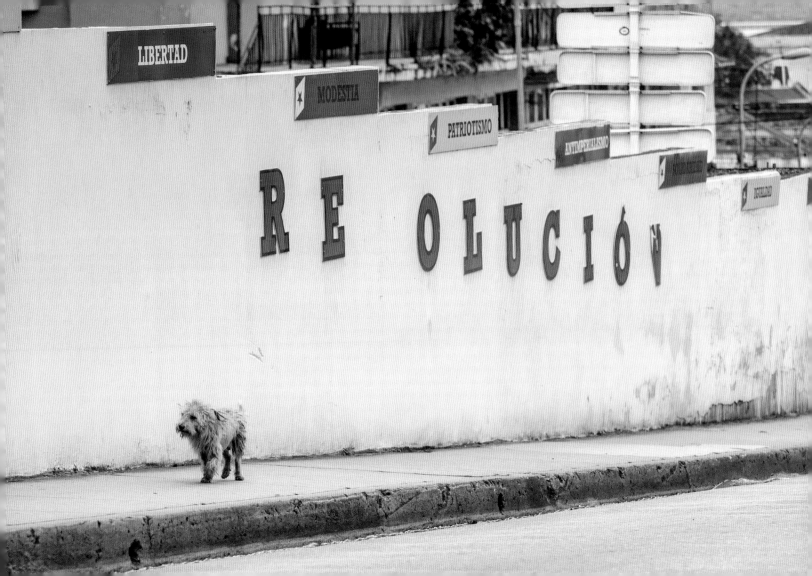

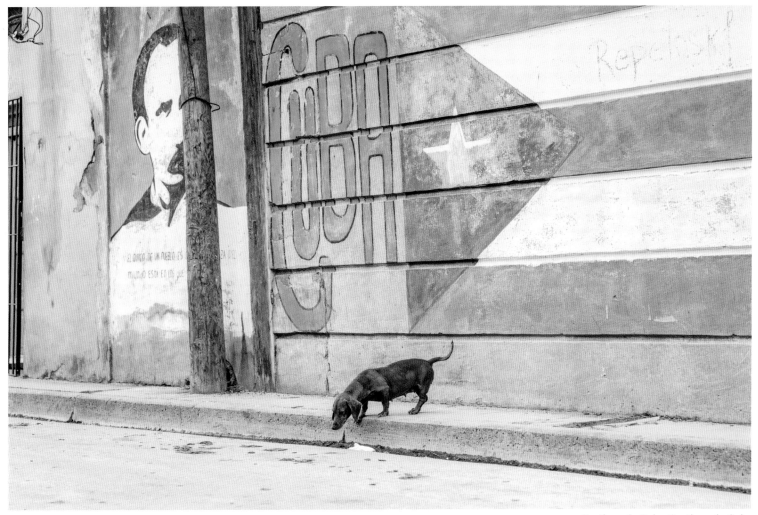

Santiago de Cuba, Santiago de Cuba

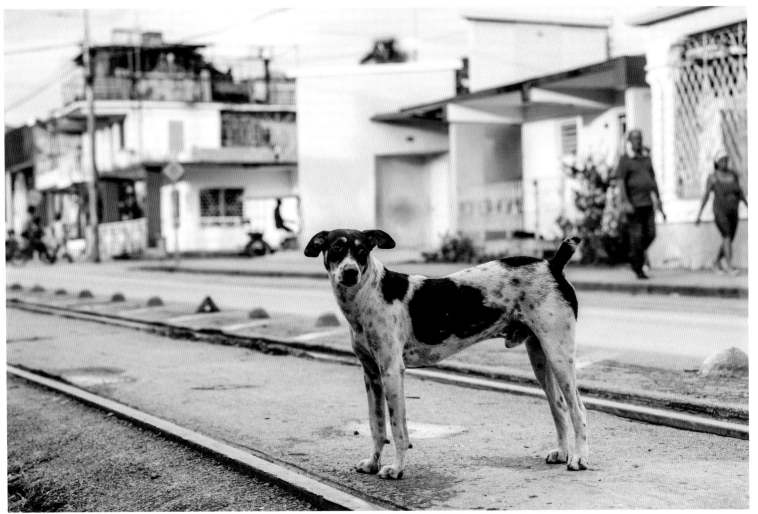

Guantánamo, Guantánamo

Baracoa, Guantánamo

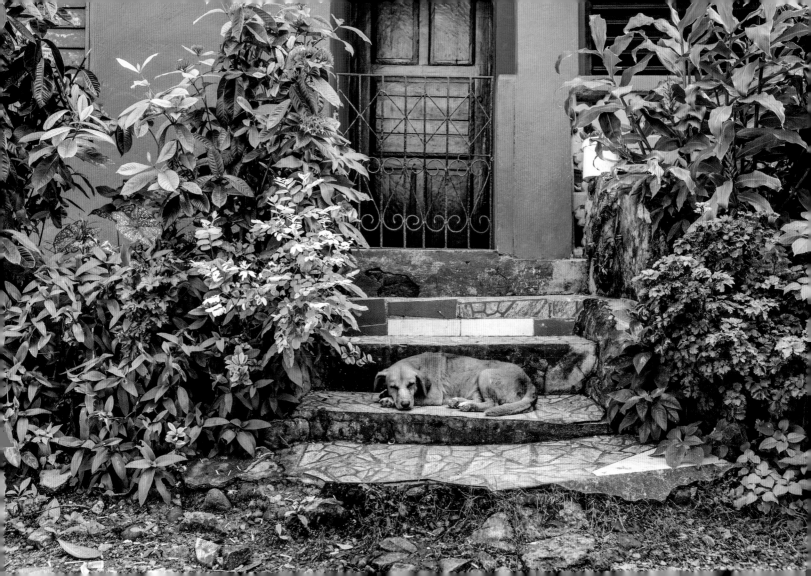

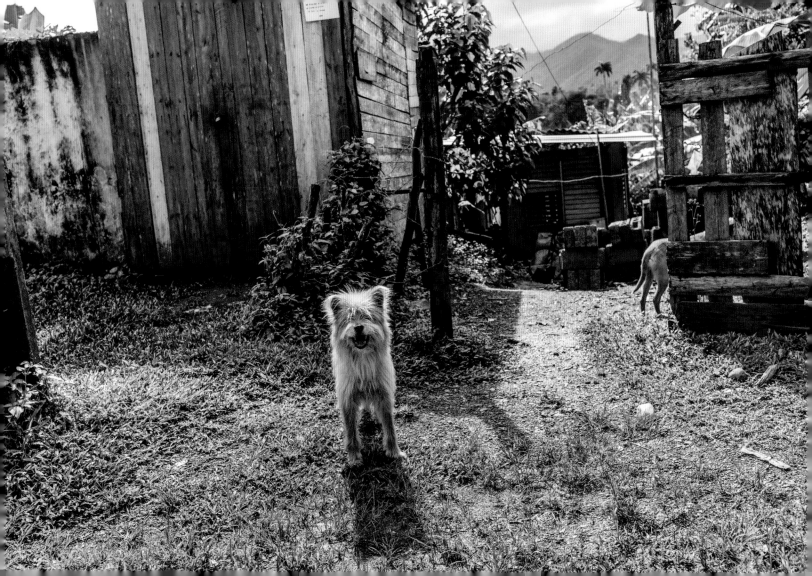

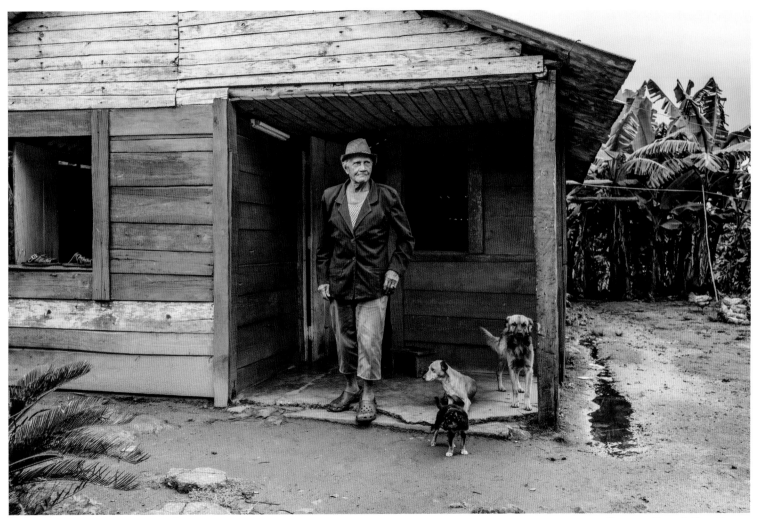

Carretera Central, Guantánamo

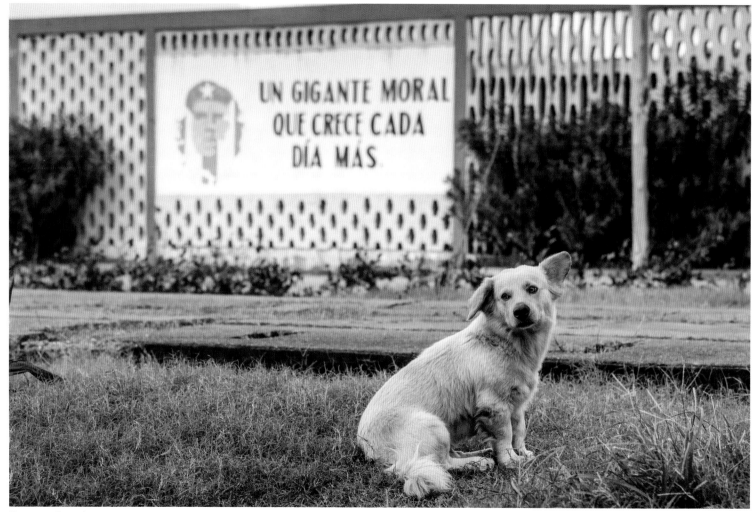

UN GIGANTE MORAL
QUE CRECE CADA
DÍA MÁS.

Baracoa, Guantánamo

Jukita, Nuni, y Kutu, Baracoa, Guantánamo

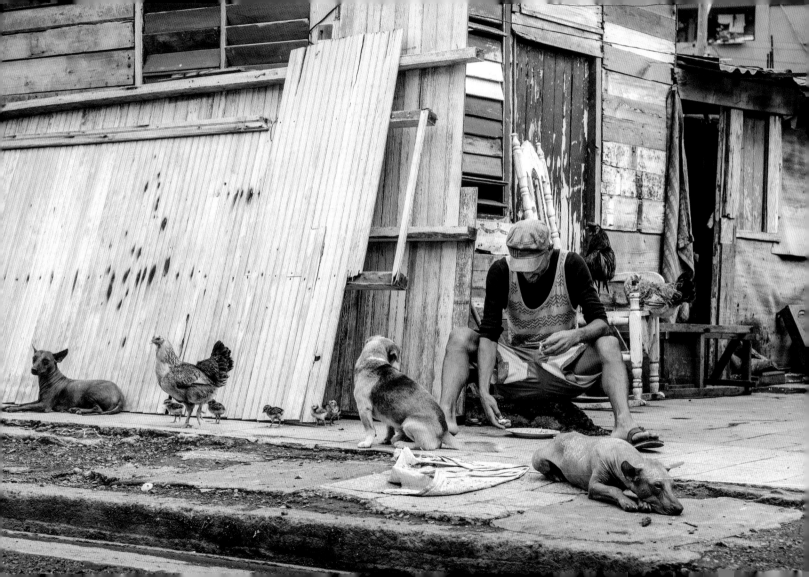

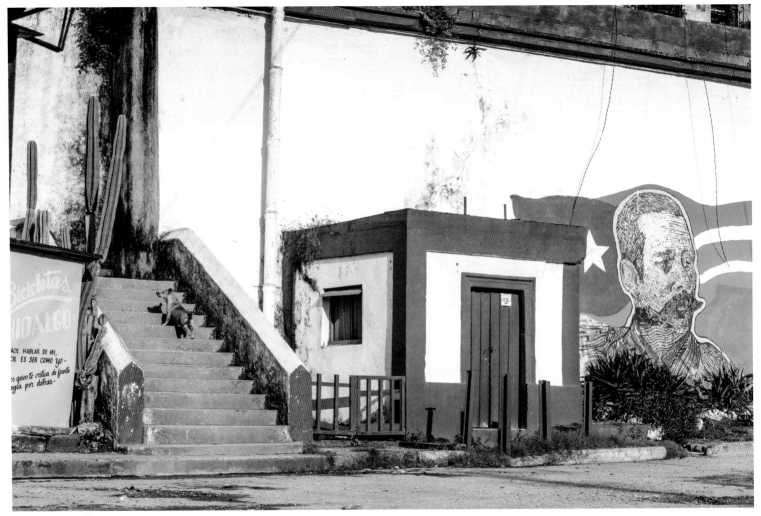

Baracoa, Guantánamo

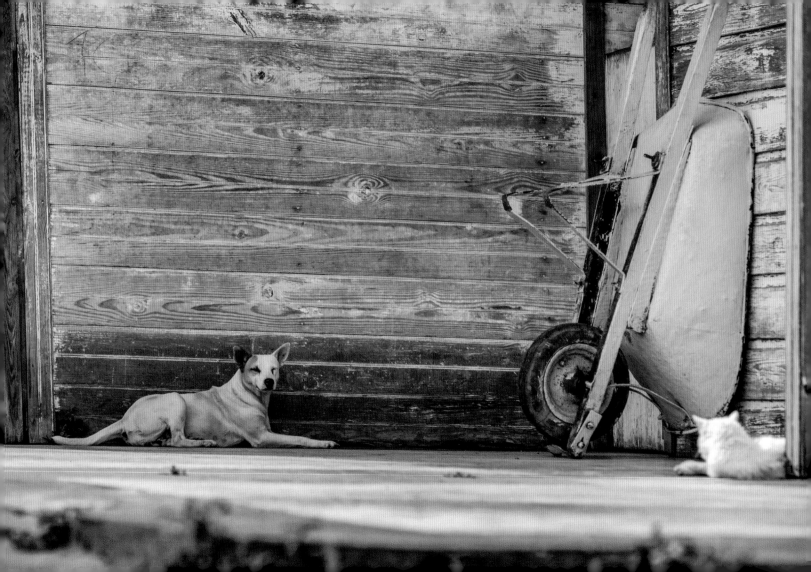

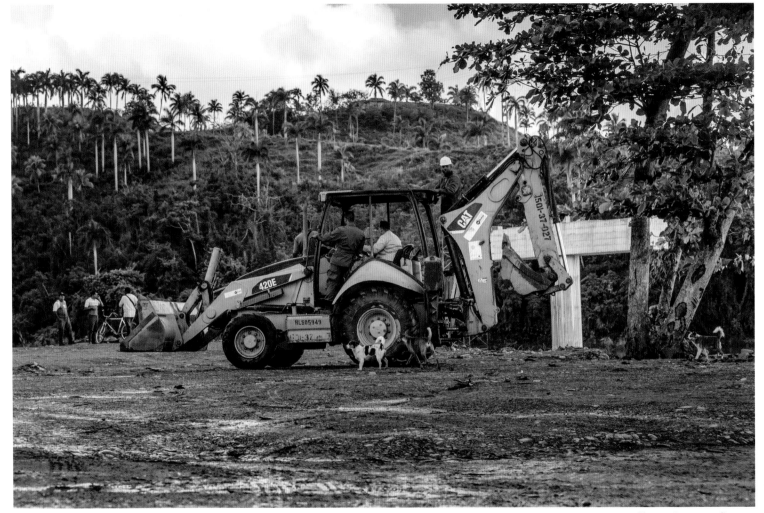

Río de Toa, Guantánamo

Shanty, Bayamo, Granma

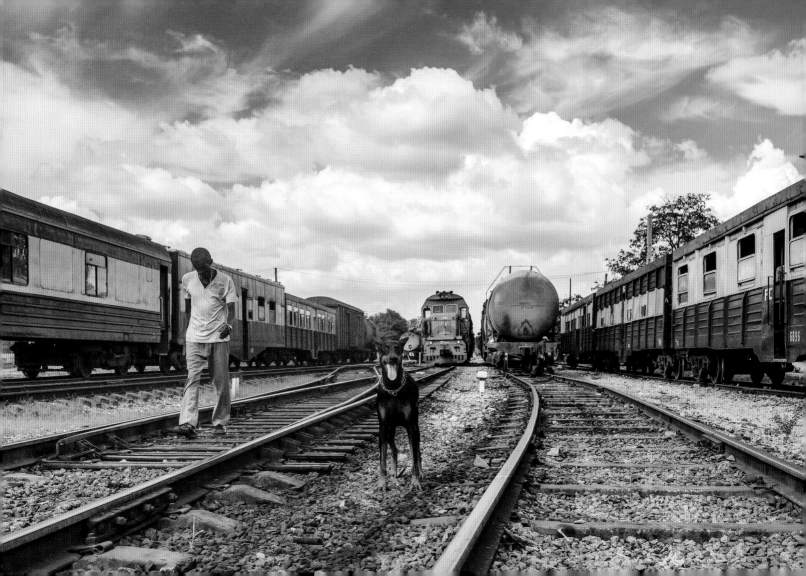

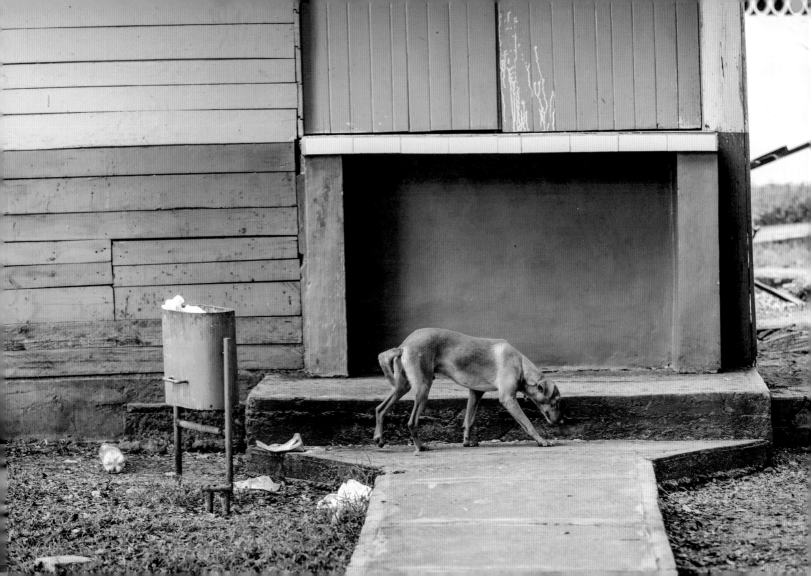

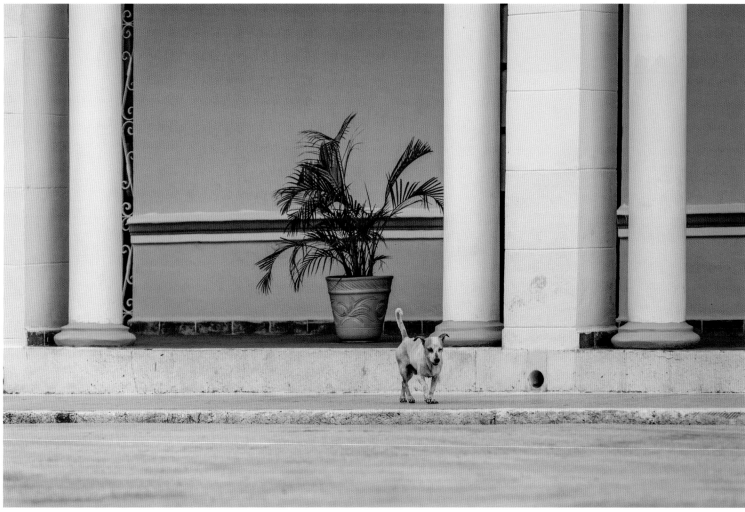

Bayamo, Granma

Hotel Royalton, Bayamo, Granma

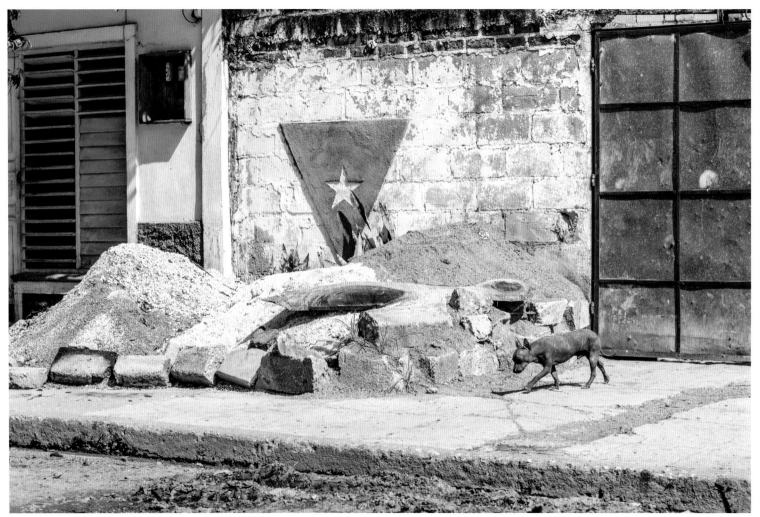

Bayamo, Granma

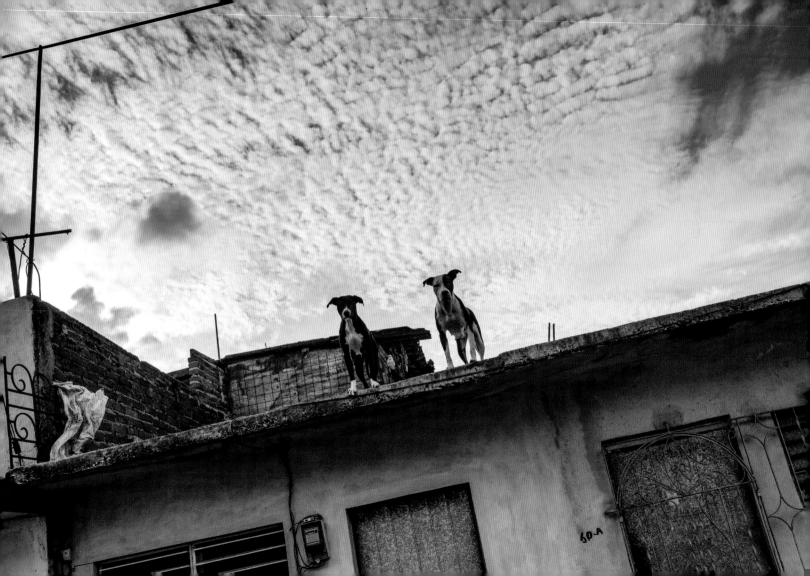

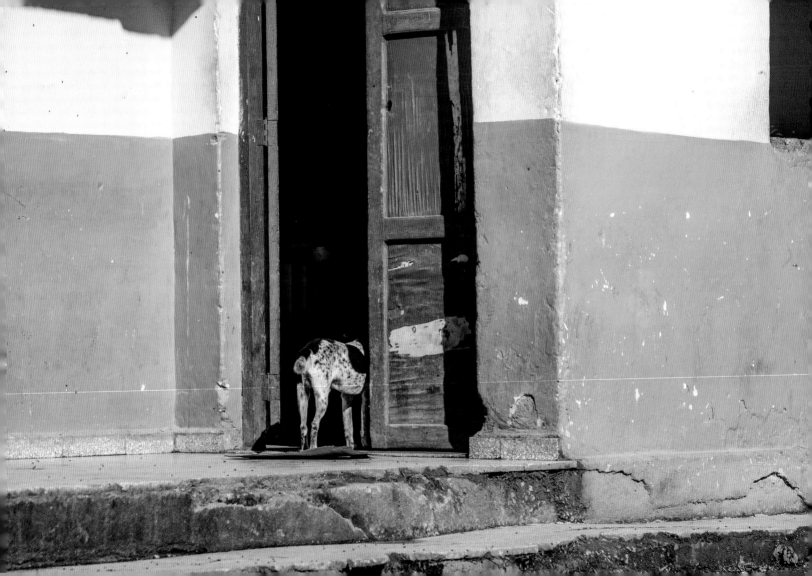

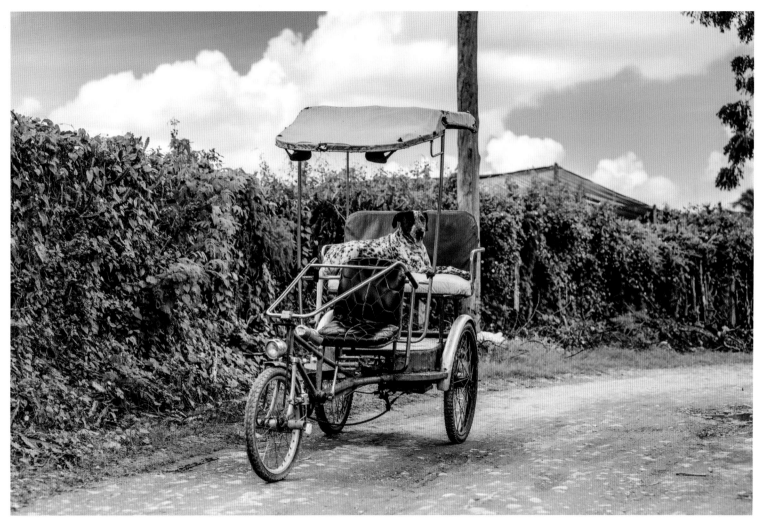

Holguín, Holguín

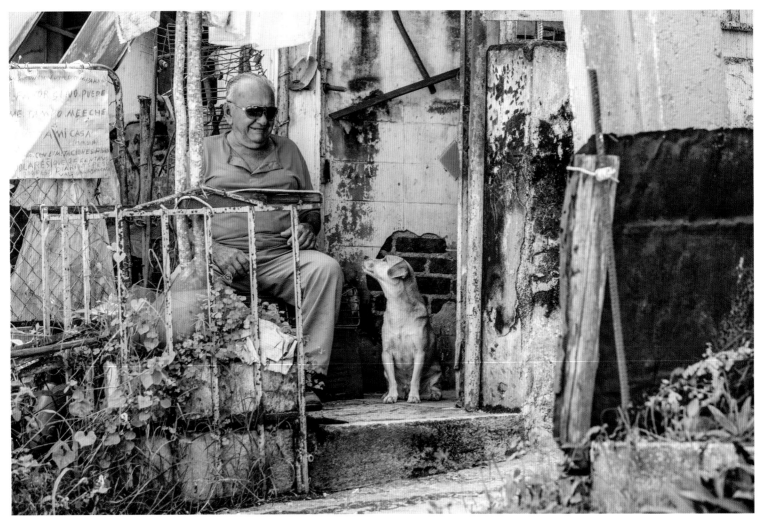

Holguín, Holguín

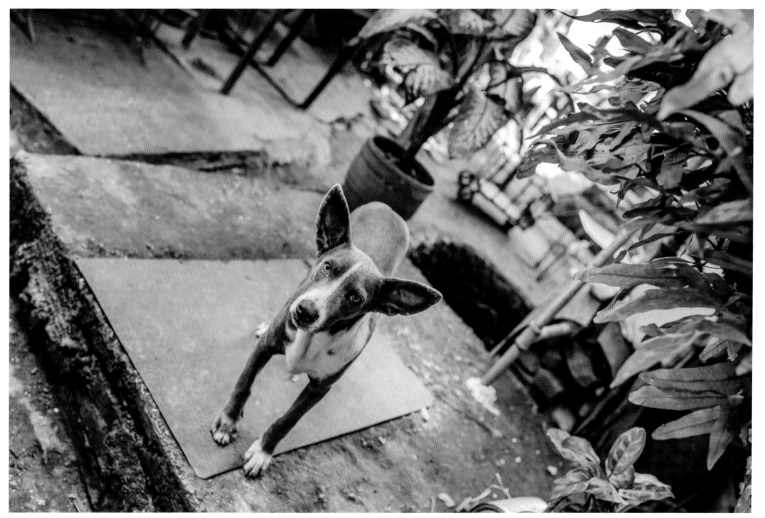

Rocky, Alcides Pino, Holguín, Holguín

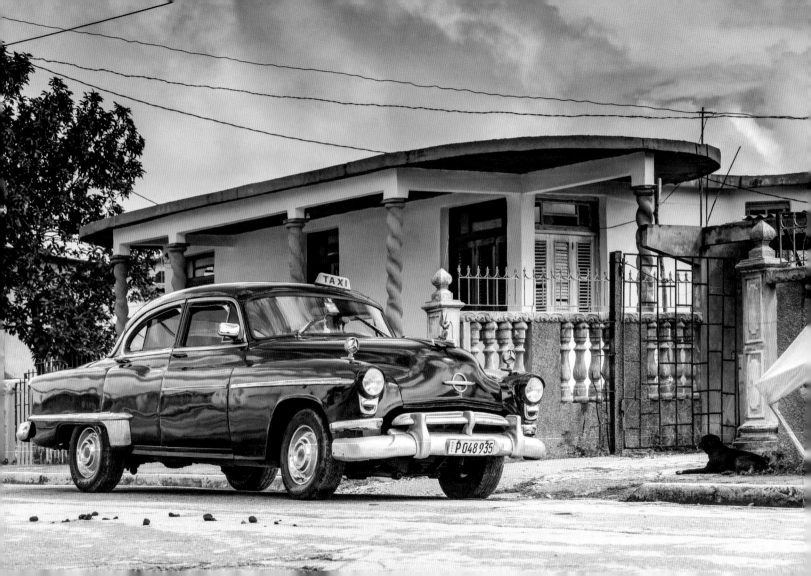

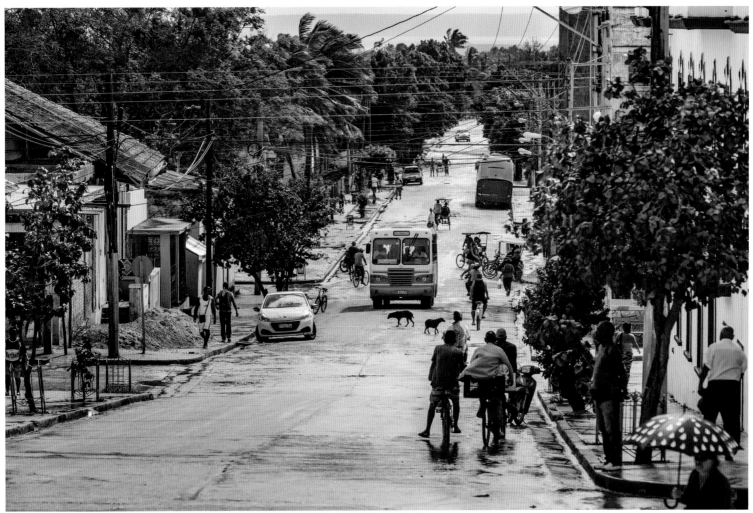

Banes, Holguín

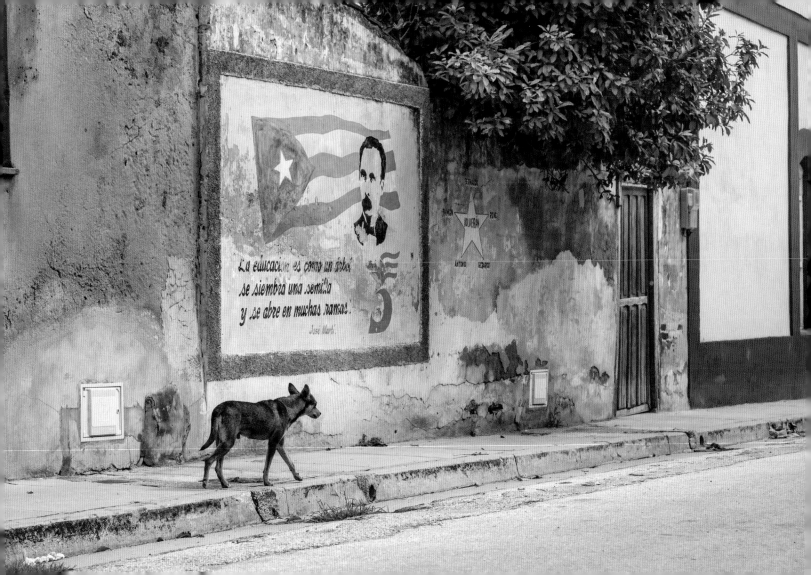

La educación es como un árbol
se siembra una semilla
y se abre en muchas ramas.

José Martí

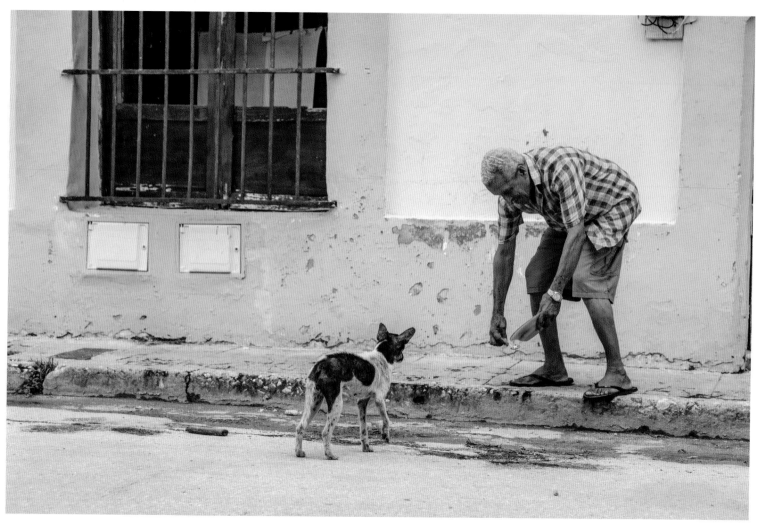

Gibara, Holguín

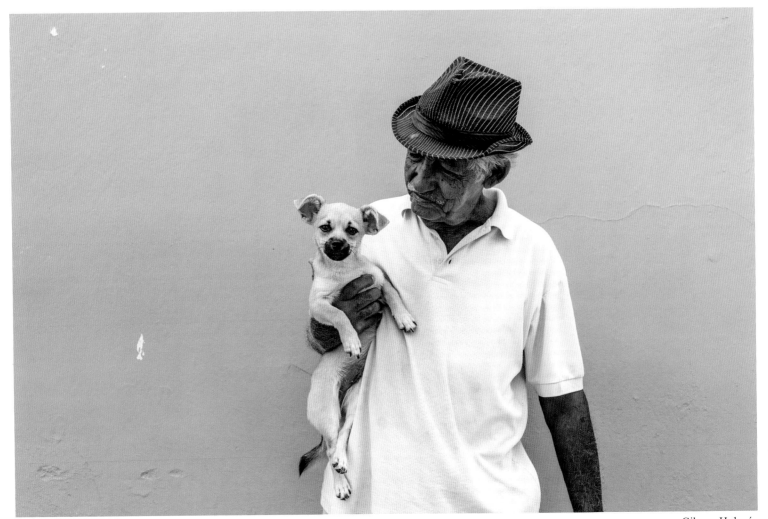

Luna, Gibara, Holguín

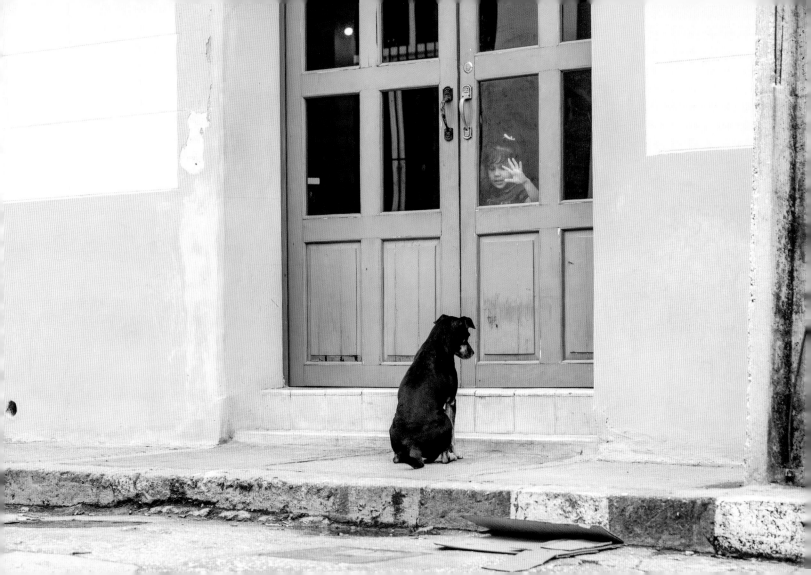

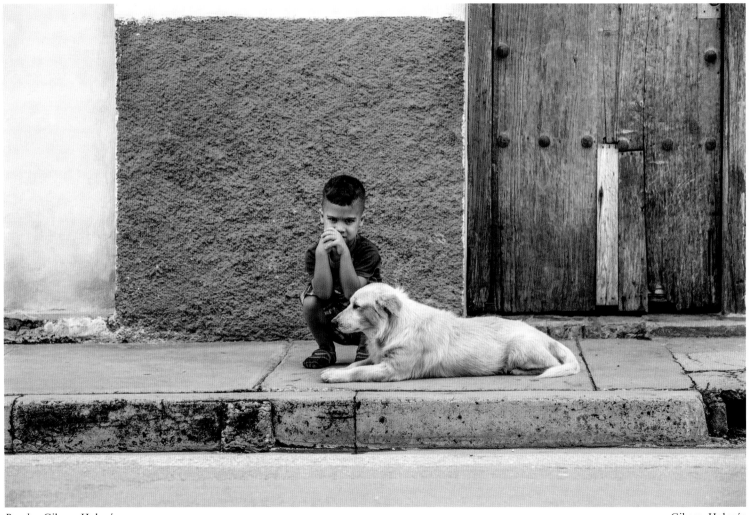

Rambo, Gibara, Holguín

Gibara, Holguín

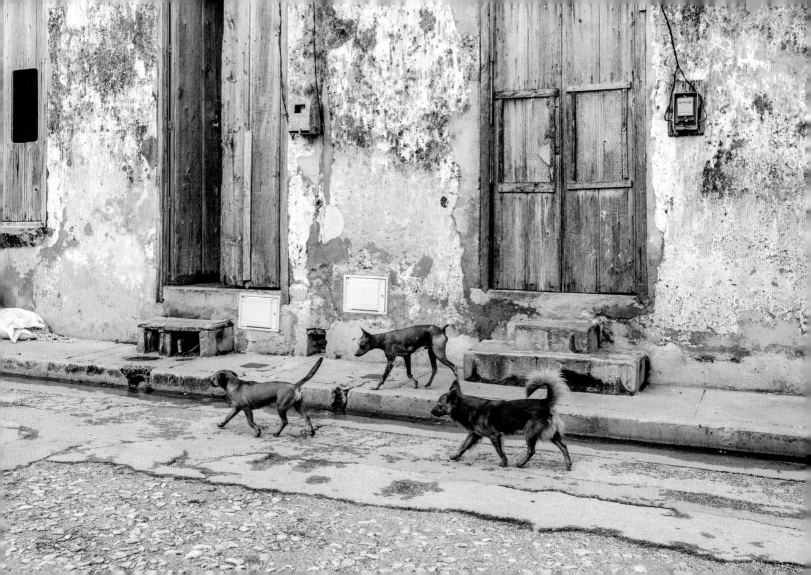

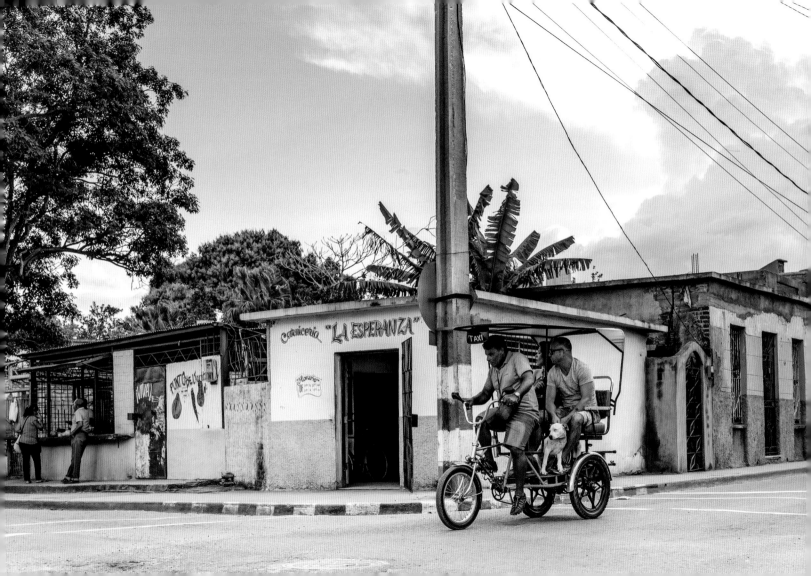

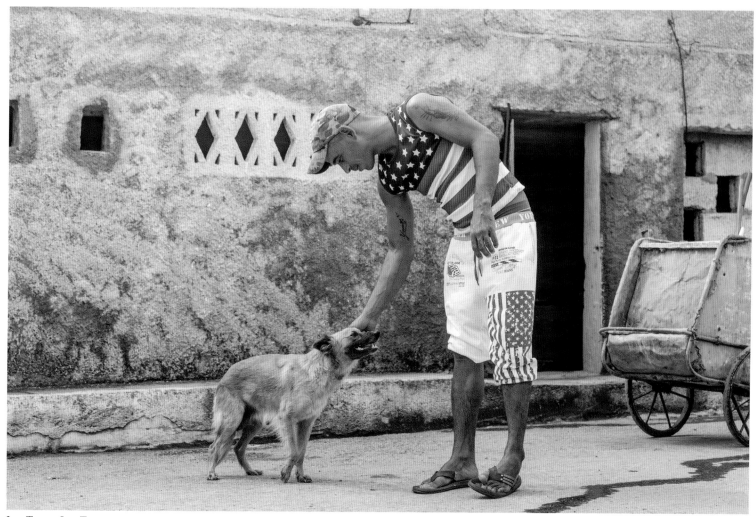

Las Tunas, Las Tunas

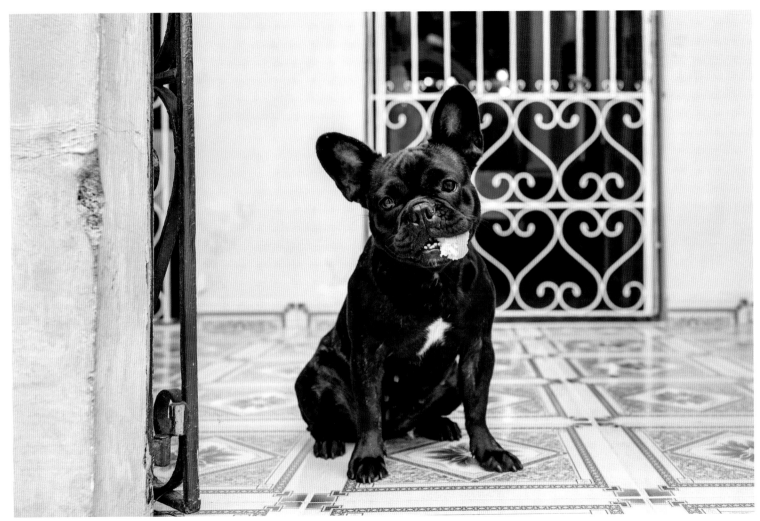

Luna, Ristorante la Romana, Las Tunas, Las Tunas

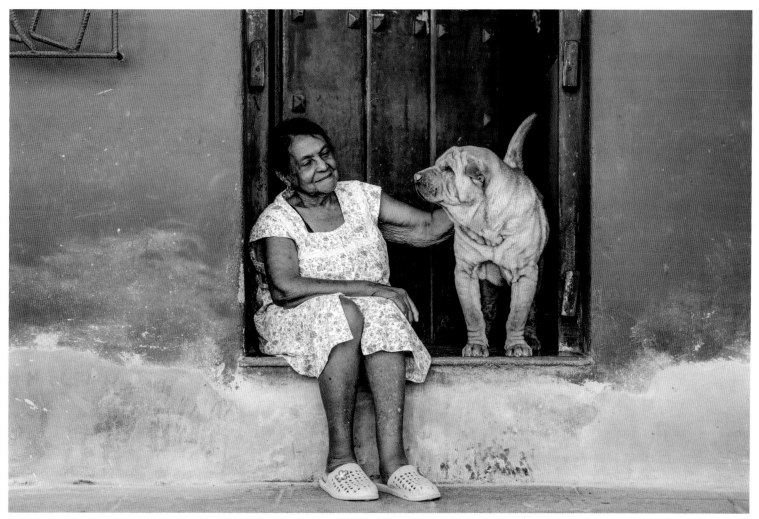

Yunper, Camagüey, Camagüey

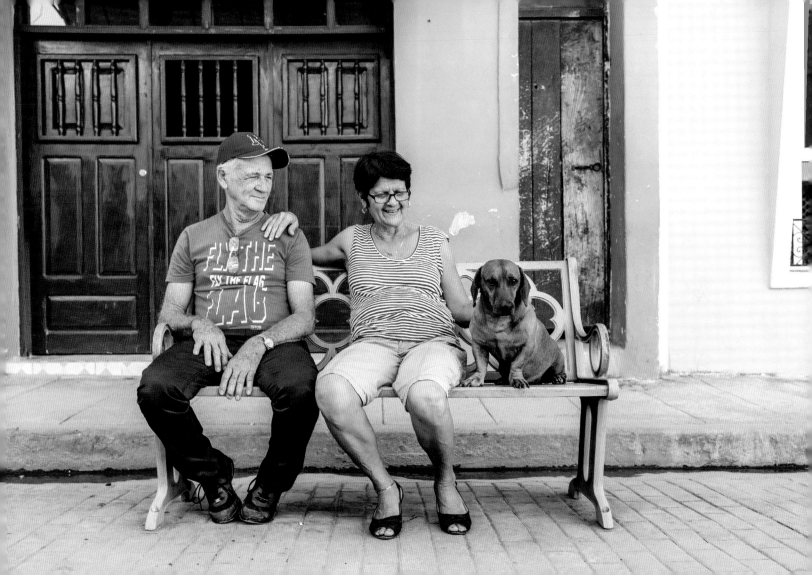

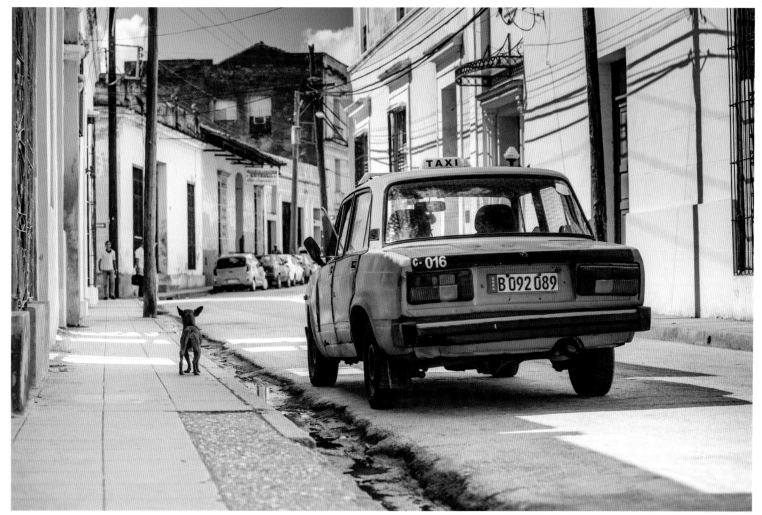

Yako, Camagüey, Camagüey

Camagüey, Camagüey

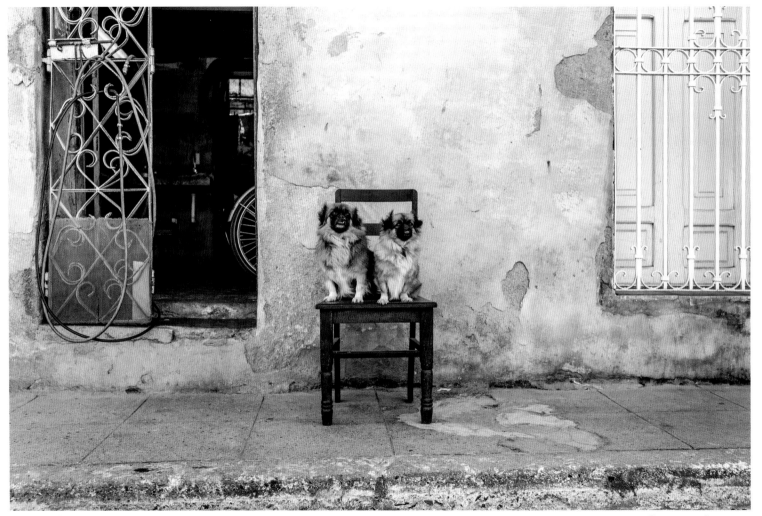

Yari y Yanko, Camagüey, Camagüey

Camagüey, Camagüey

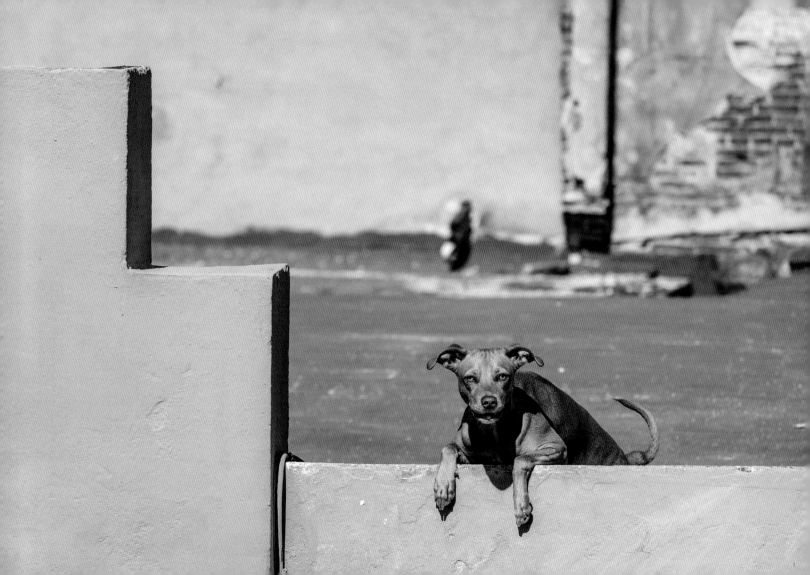

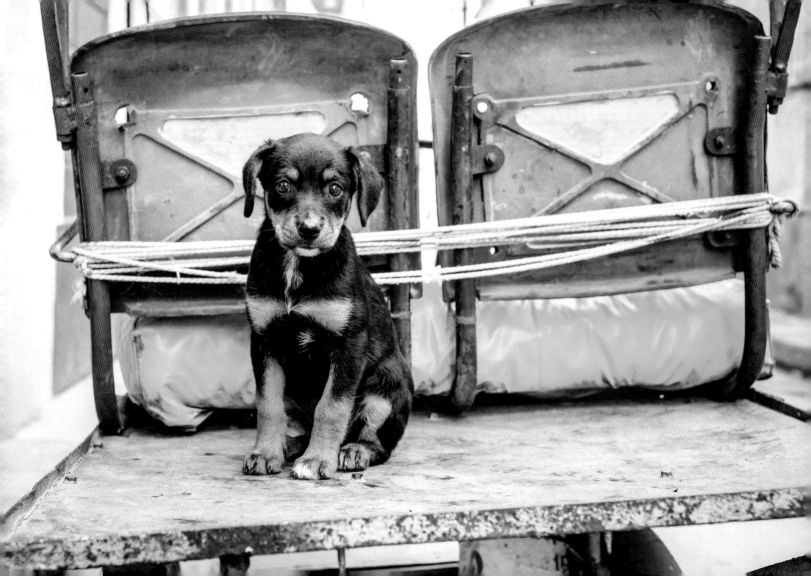

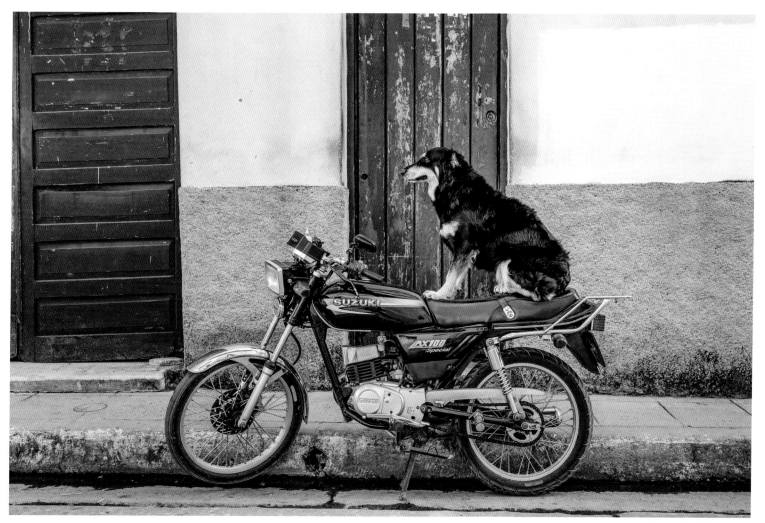

Camagüey, Camagüey

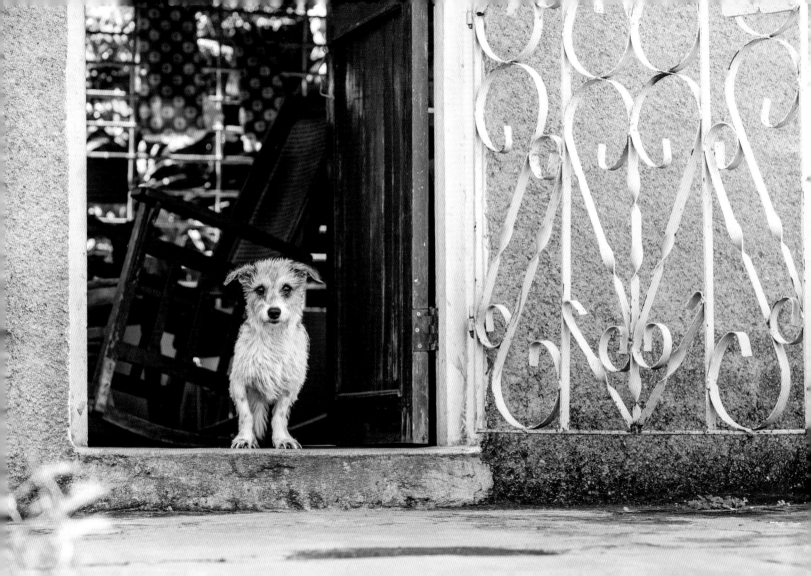

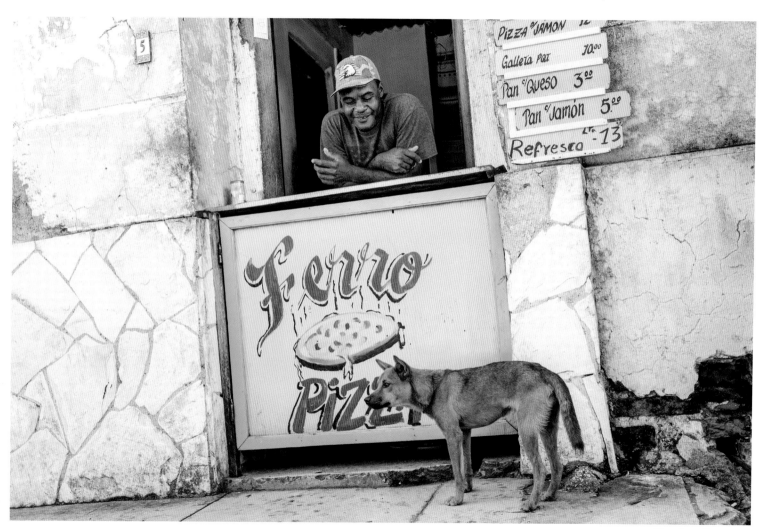

PIZZA JAMON 12
Galleta Pai 10.00
Pan Queso 3.00
Pan Jamón 5.00
Refresco -13

Ferro Pizza

Nuevitas, Camagüey

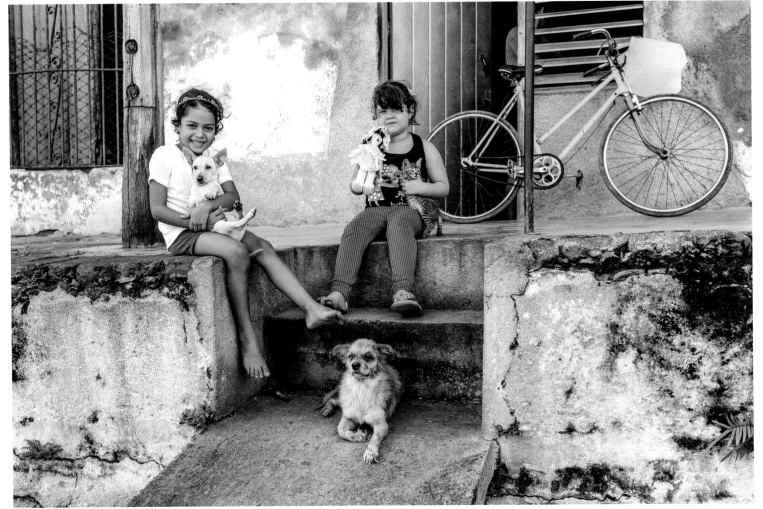

Nuevitas, Camagüey

Princesa y Dino, Florida, Camagüey

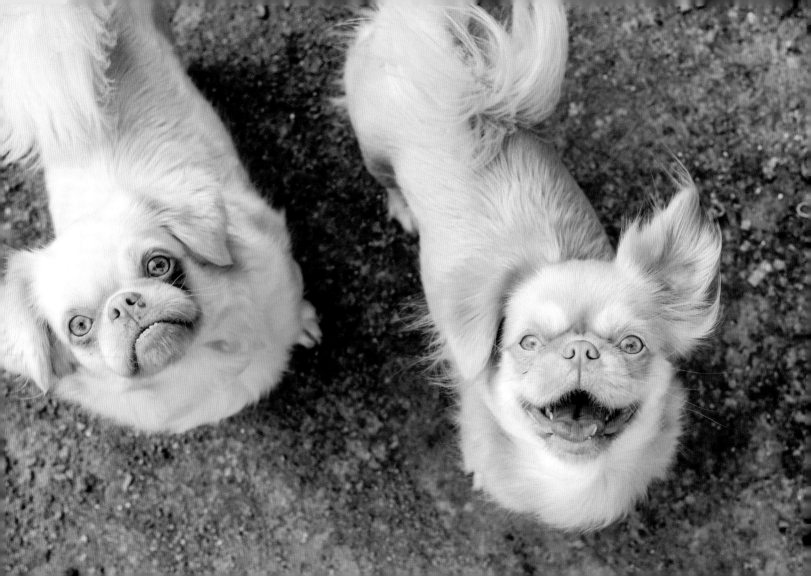

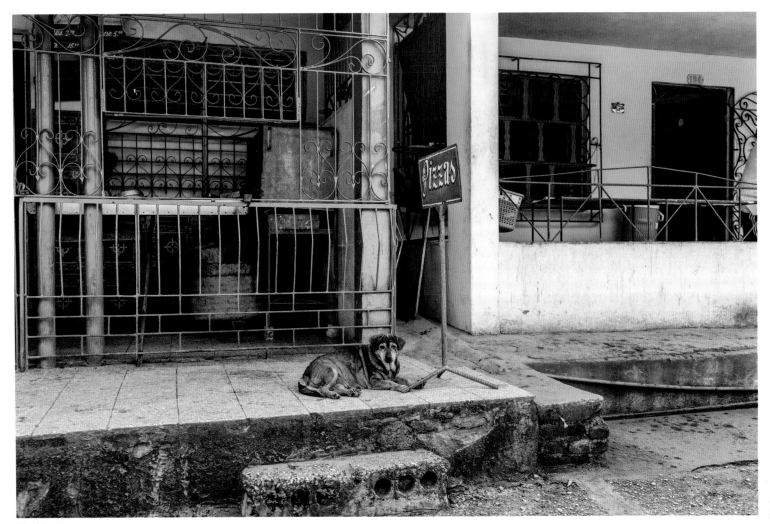

Florida, Camagüey

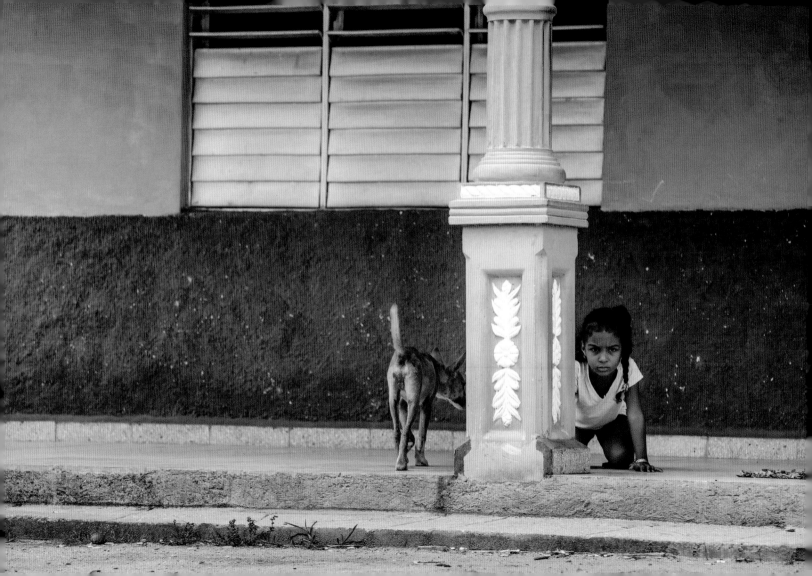

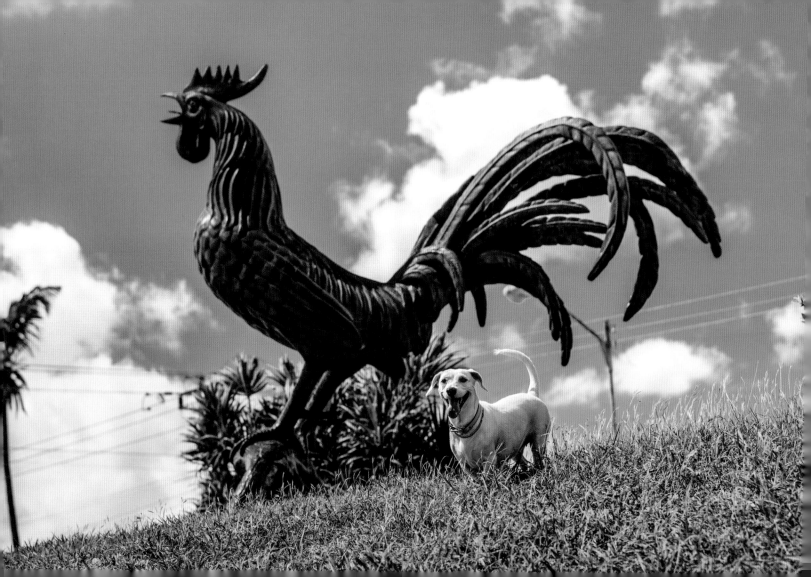

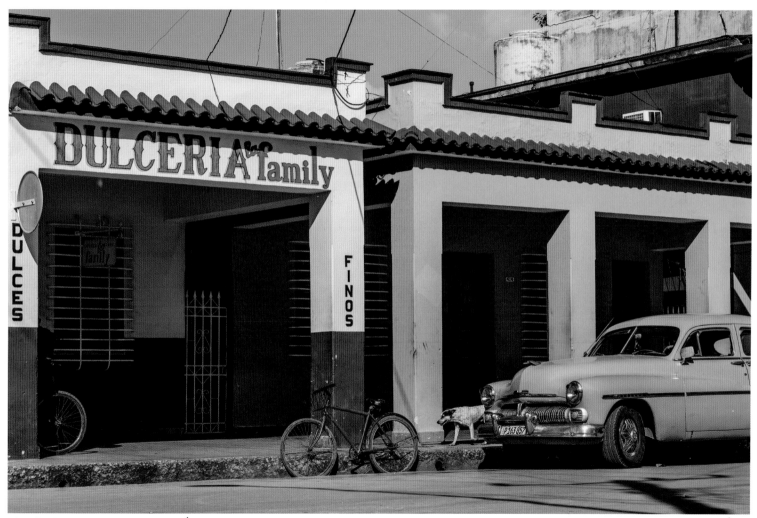

El Gallo de Morón, Morón, Ciego de Ávila

Morón, Ciego de Ávila

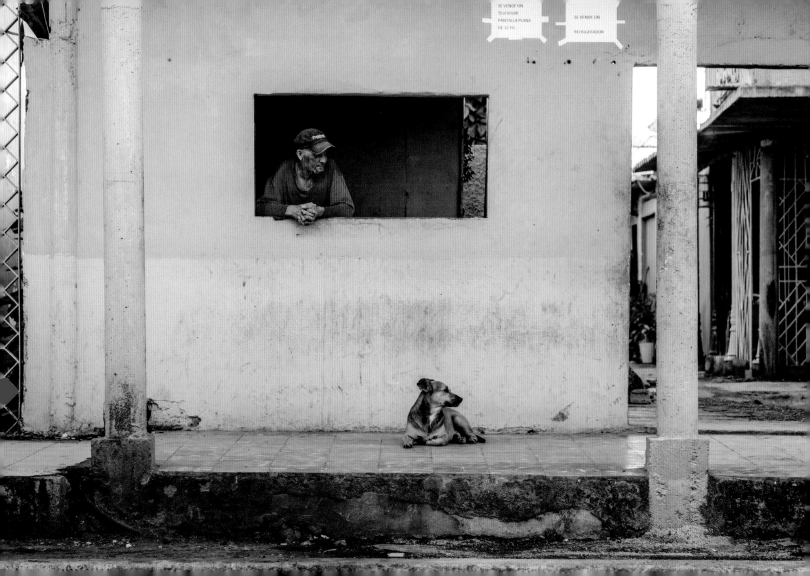

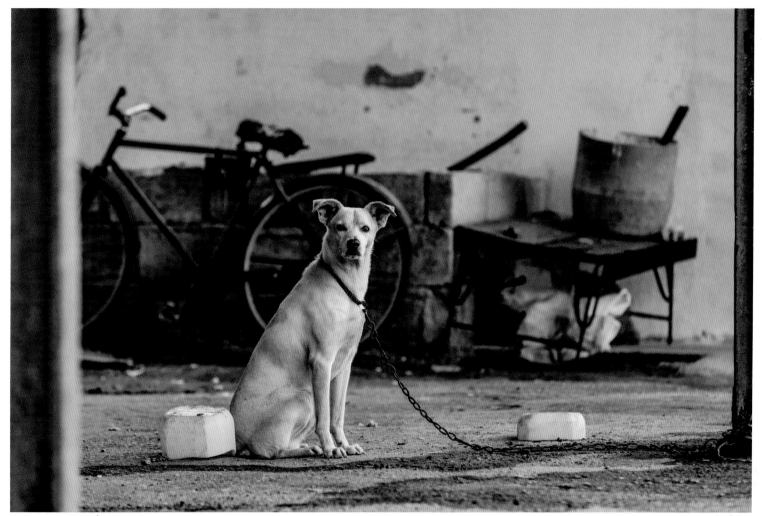

Morón, Ciego de Ávila

Moti, Morón, Ciego de Ávila

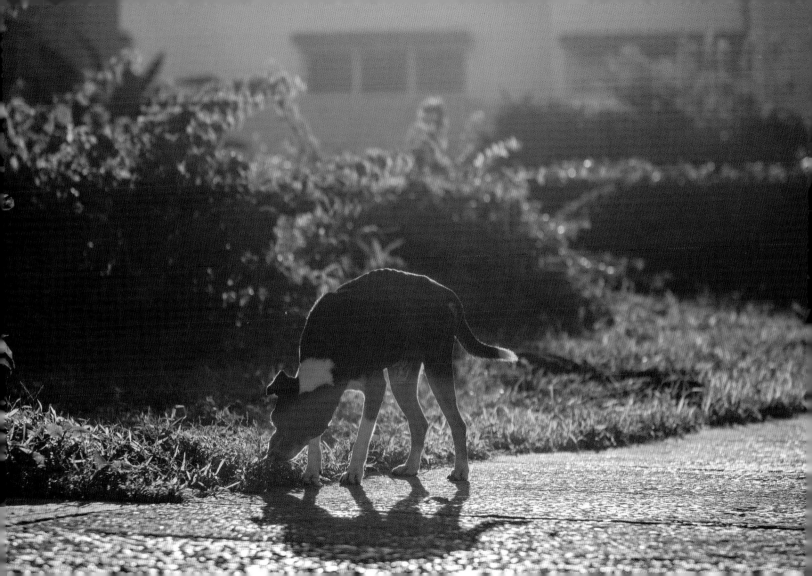

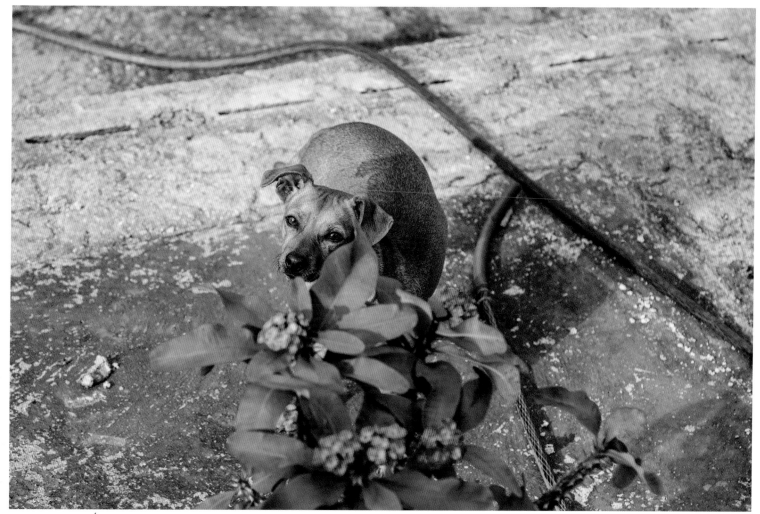

Morón, Ciego de Ávila

Tina, Morón, Ciego de Ávila

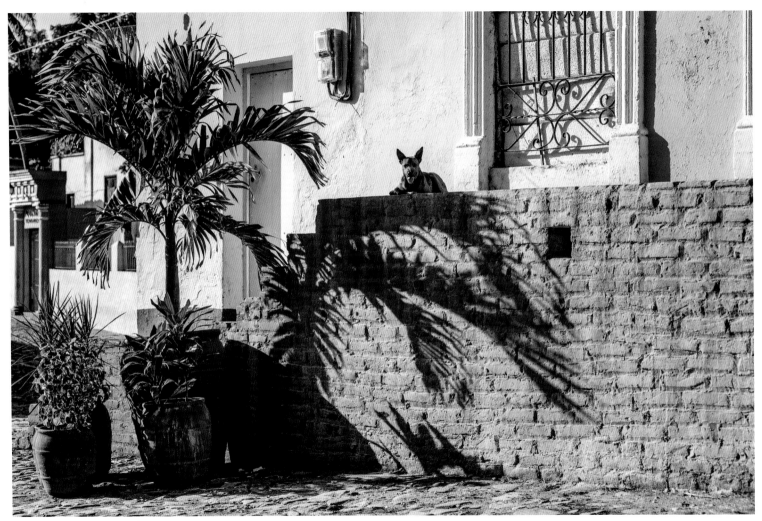

Sancti Spíritus, Sancti Spíritus

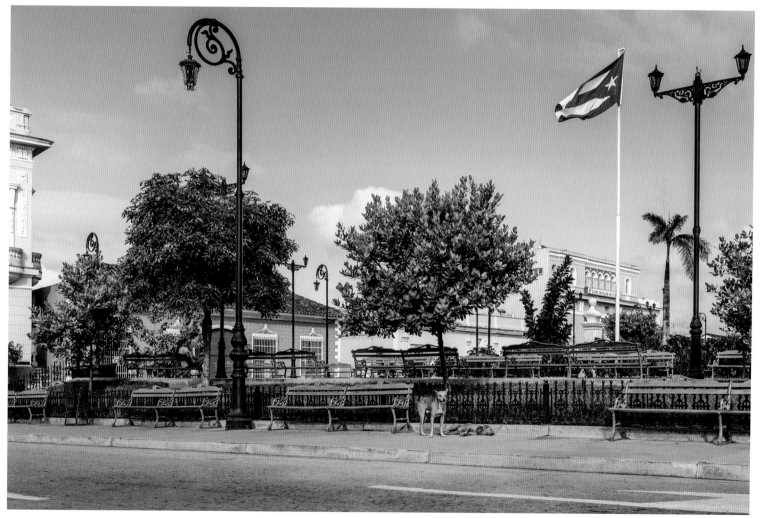

Parque Serafín Sánchez, Sancti Spíritus, Sancti Spíritus

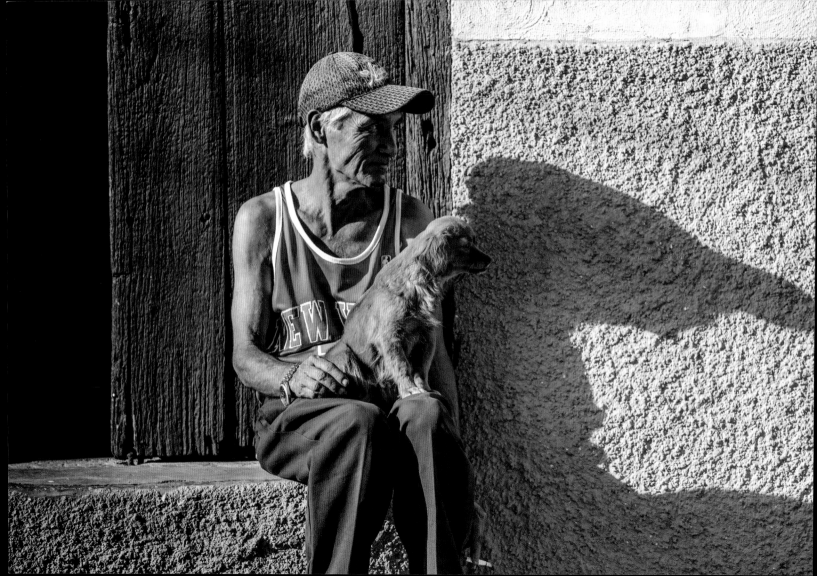

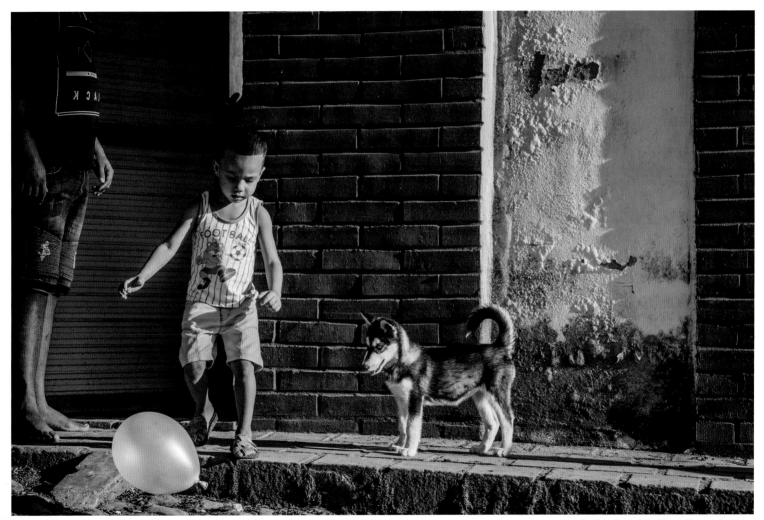

Leila, Sancti Spíritus, Sancti Spíritus

Laika, Sancti Spíritus, Sancti Spíritus

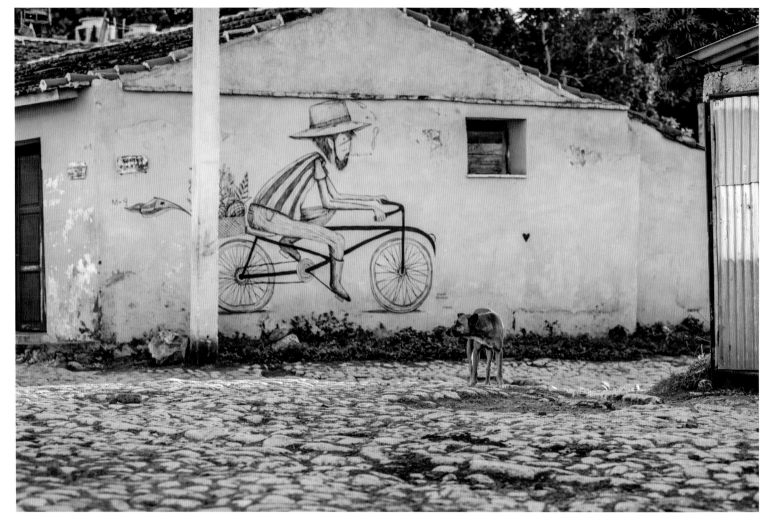

Mural by Bruno Malagrino, Trinidad, Sancti Spíritus

Trinidad, Sancti Spíritus

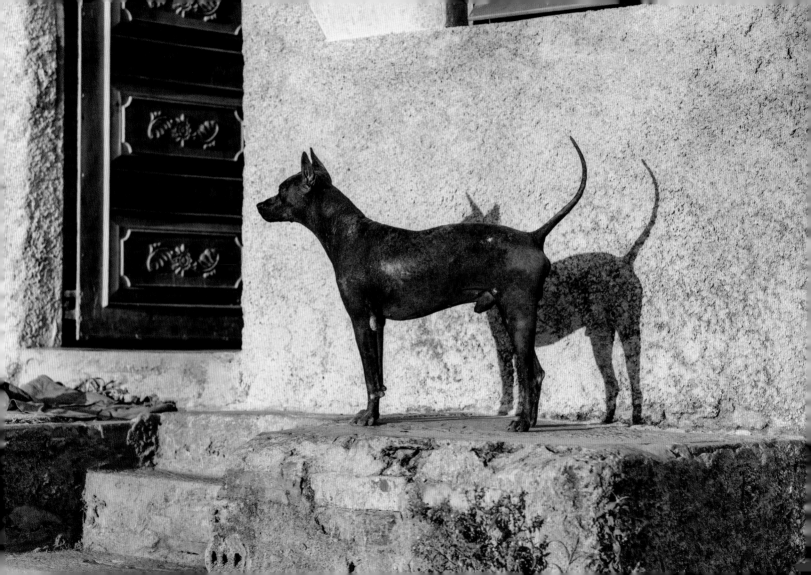

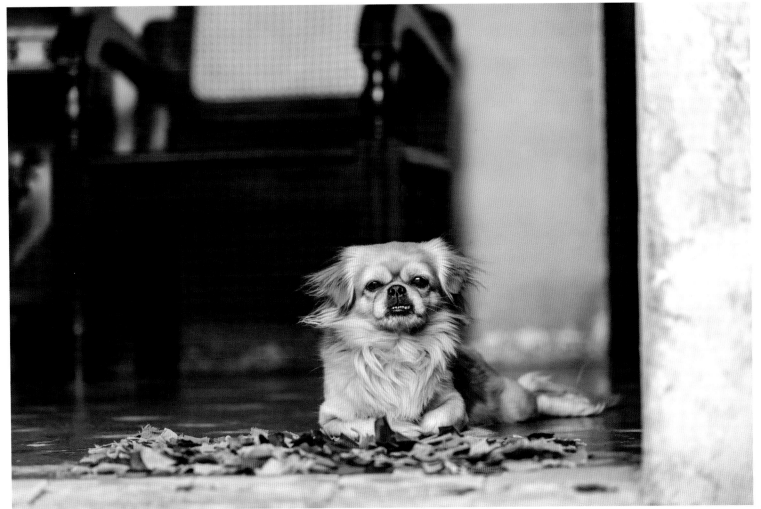

Carlo, Trinidad, Sancti Spíritus

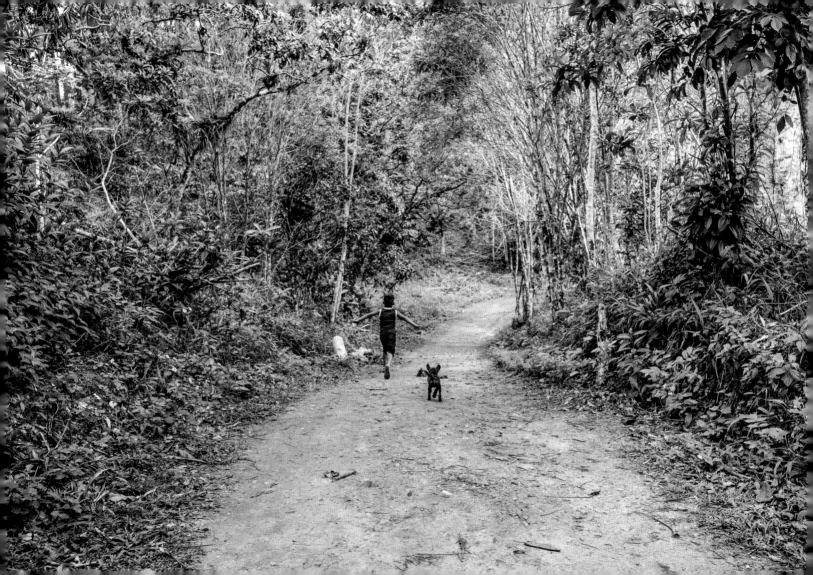

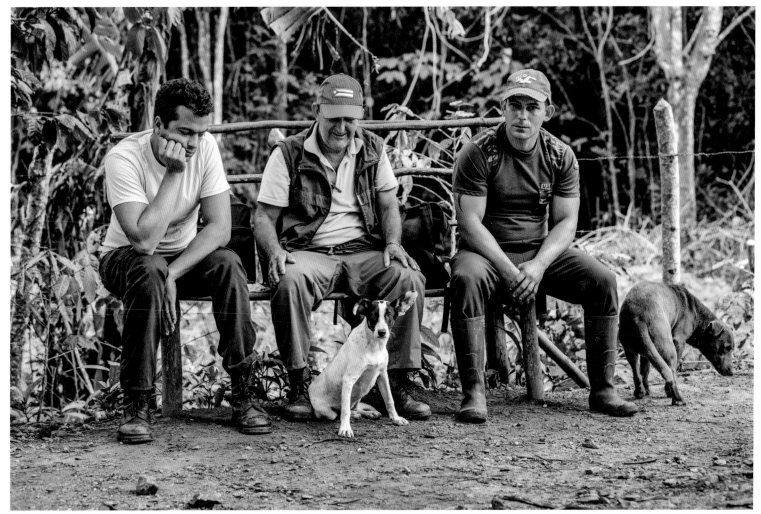

Burudo, Topes de Collantes, Sancti Spíritus

Luna, Topes de Collantes, Sancti Spíritus

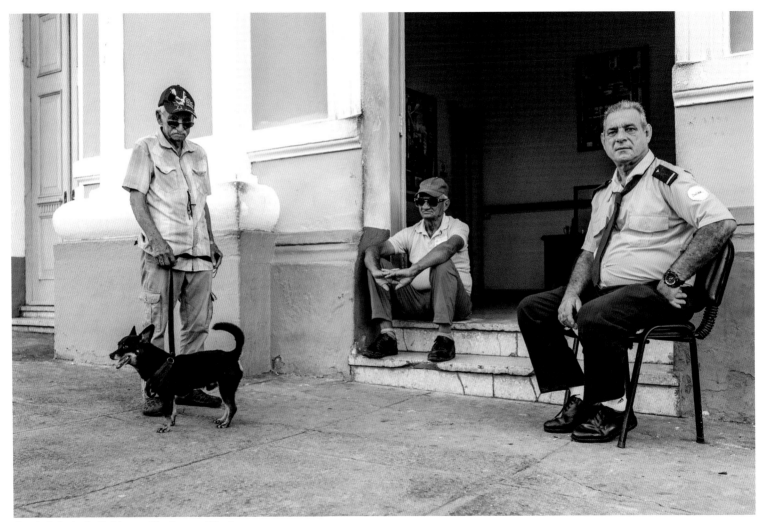

Jacob, Palacio de Gobierno, Cienfuegos, Cienfuegos

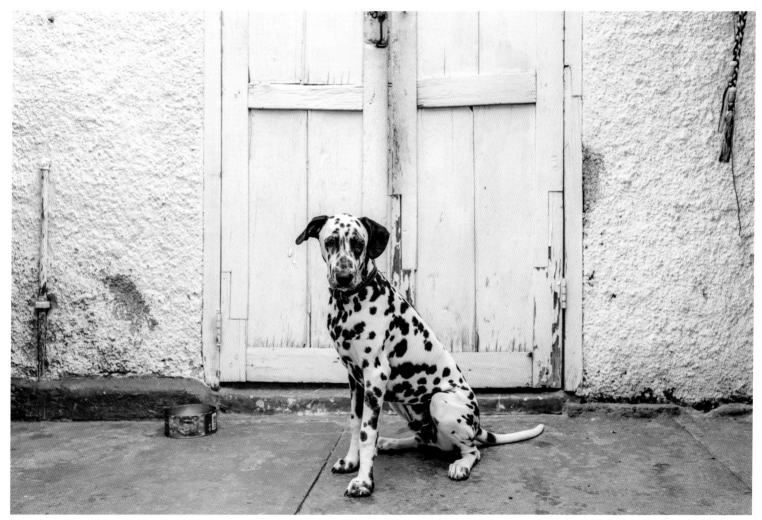

Milan, Cienfuegos, Cienfuegos

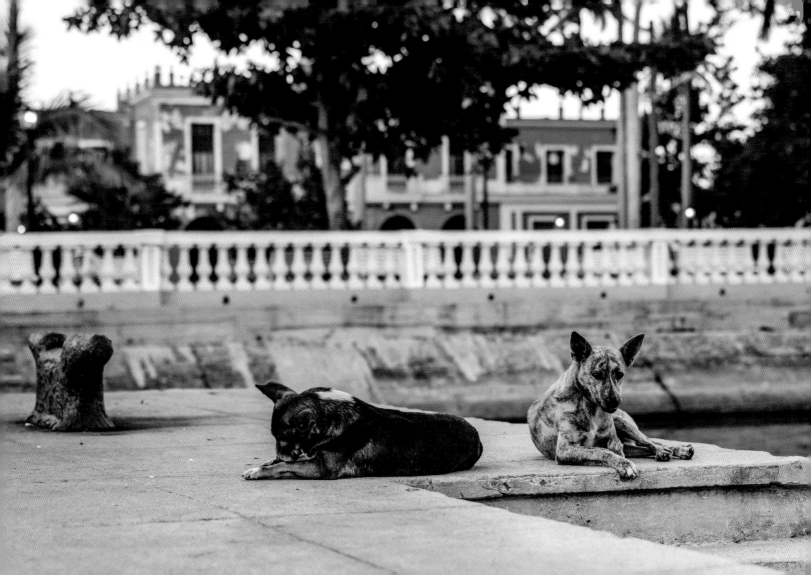

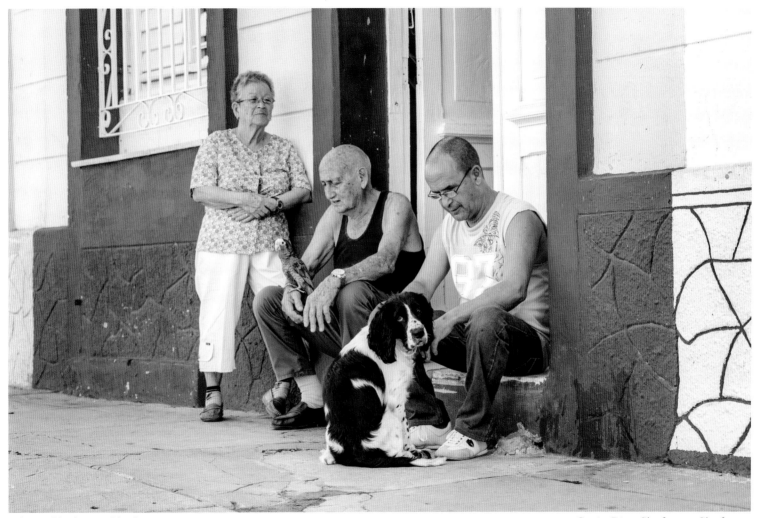

Aduana, Cienfuegos, Cienfuegos

Corti y Dino, Cienfuegos, Cienfuegos

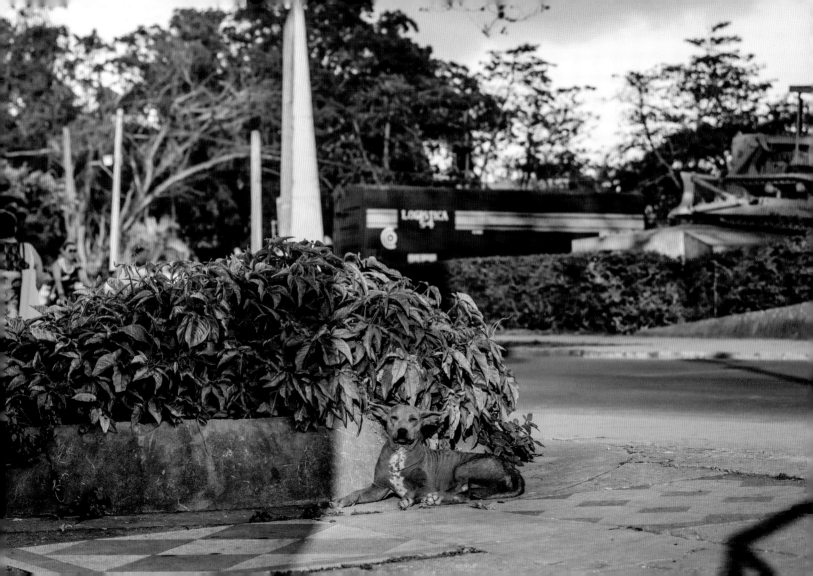

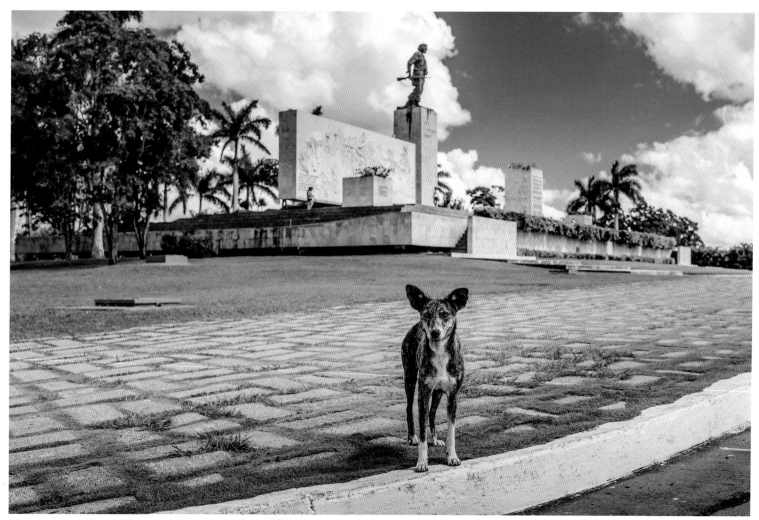

Monumento a la Toma del Tren Blindado, Santa Clara, Villa Clara

Che Guevara Mausoleum, Santa Clara, Villa Clara

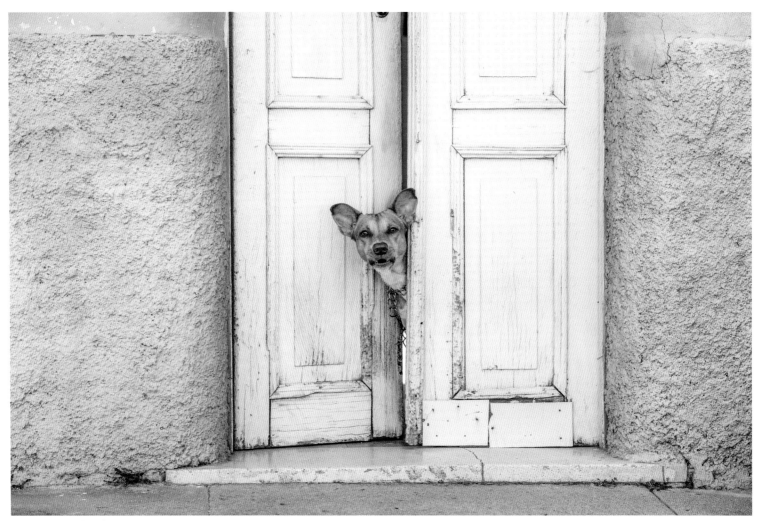

Santa Clara, Villa Clara

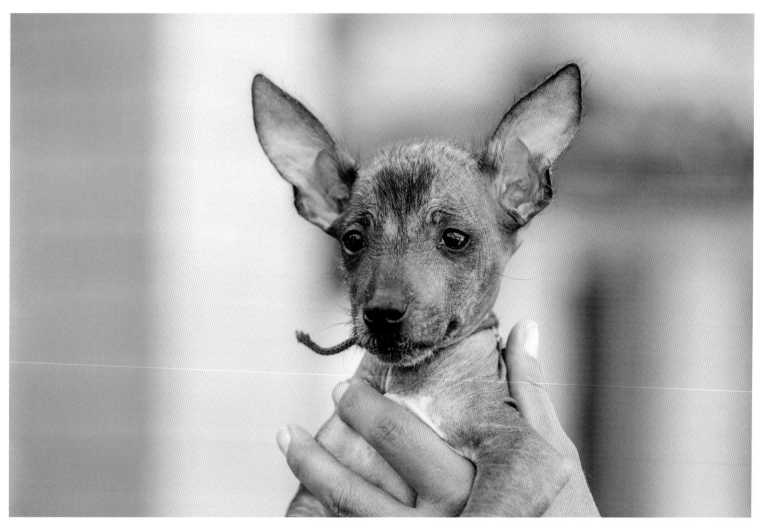

Sadi, Santa Clara, Villa Clara

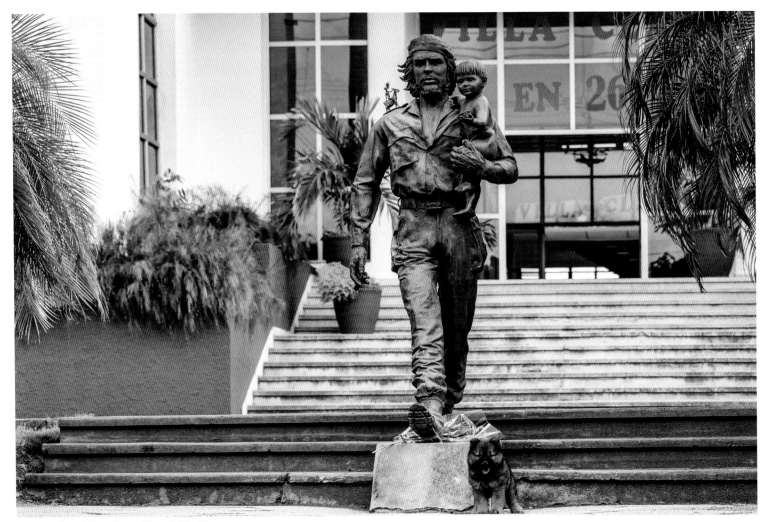

Estatua Che y Niño, Santa Clara, Villa Clara

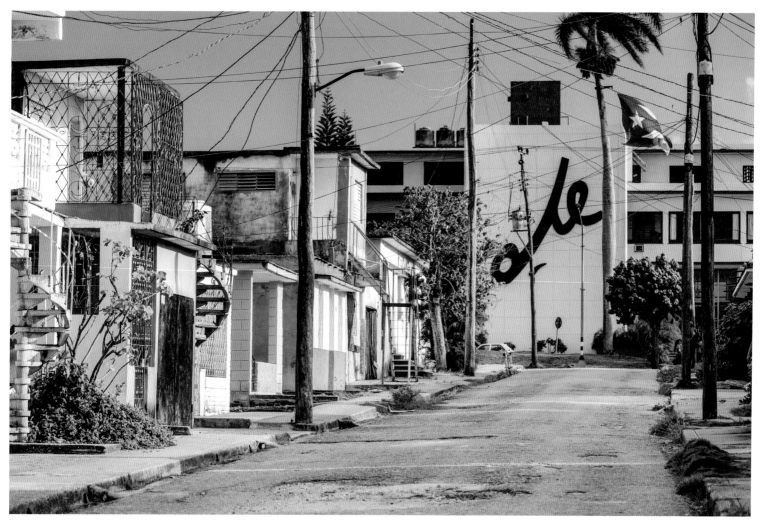

Barbie, Santa Clara, Villa Clara

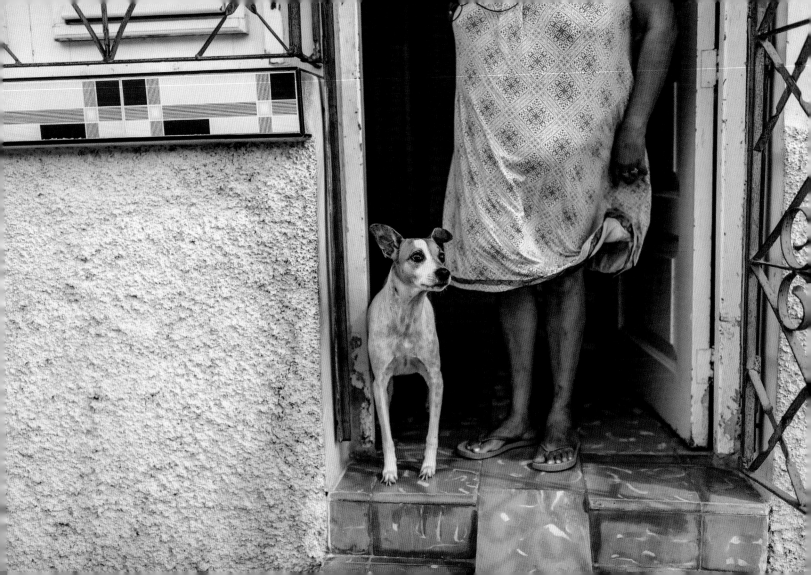

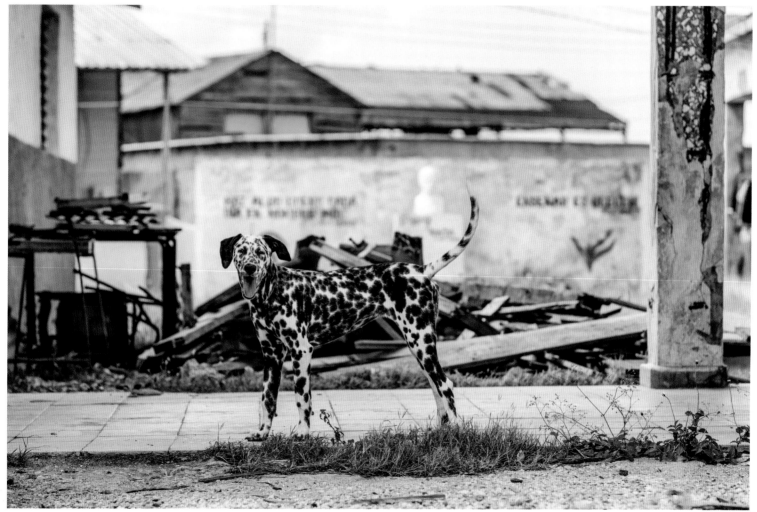

Santa Clara, Villa Clara

Sasha, Isabela de Sagua, Villa Clara

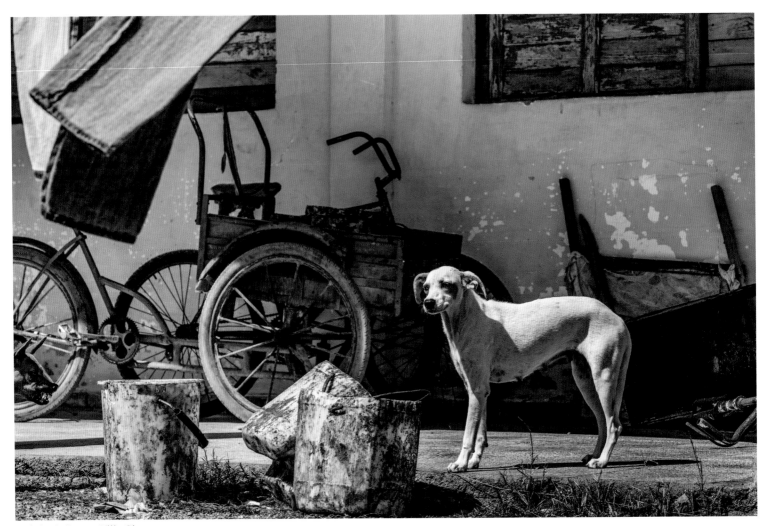

Isabela de Sagua, Villa Clara

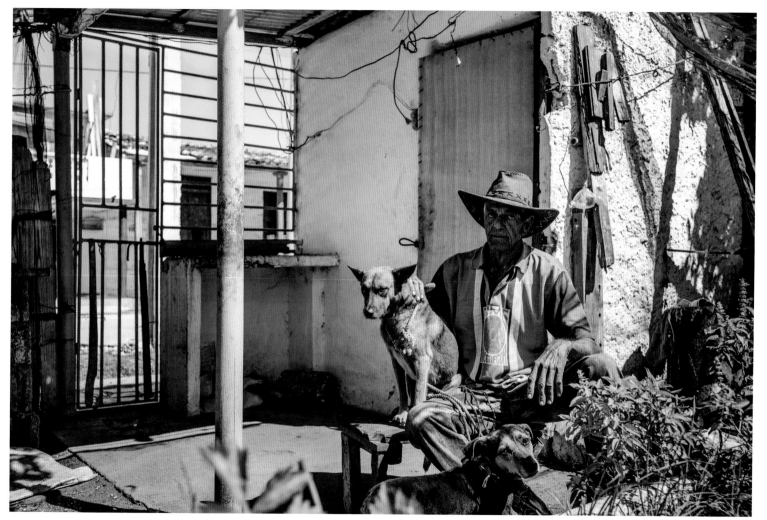

Callejero y Weso, Caibarién, Villa Clara

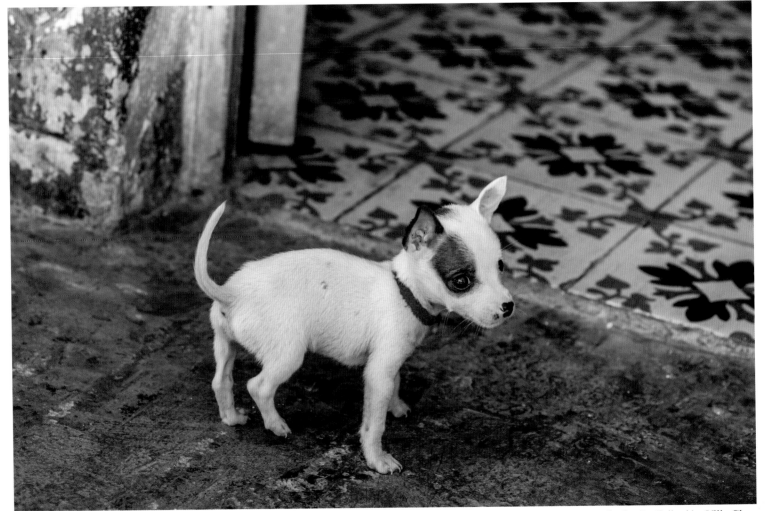

Sophia, Caibarién, Villa Clara

Gachopin, Caibarién, Villa Clara

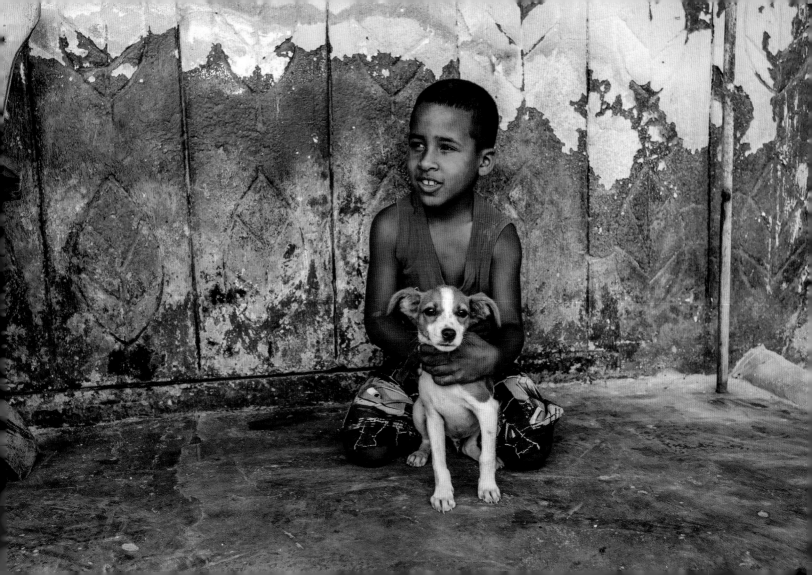

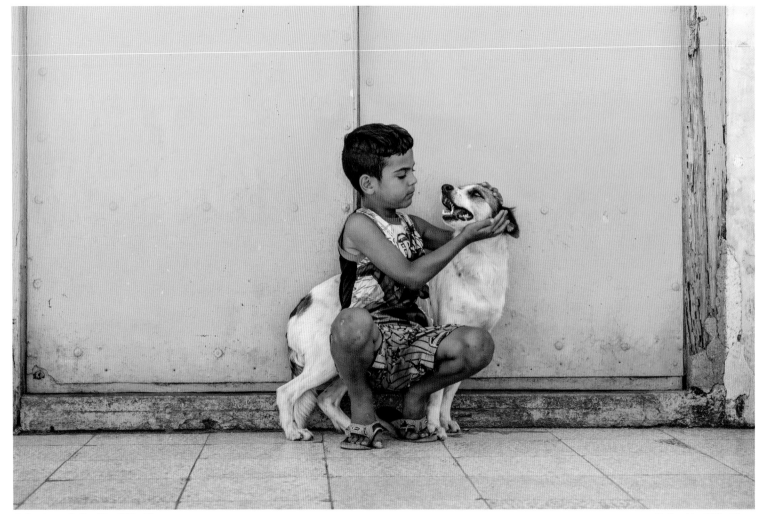

Salvadora, Caibarién, Villa Clara

Caibarién, Villa Clara

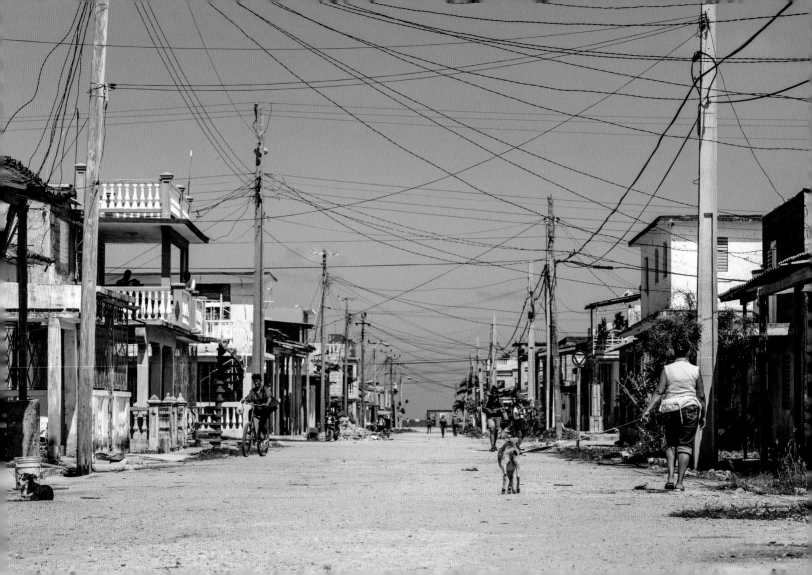

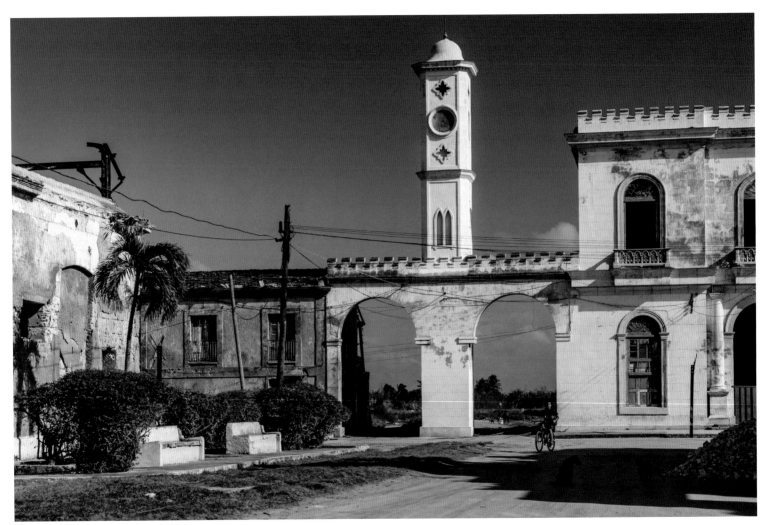

Estación San Martín, Cárdenas, Matanzas

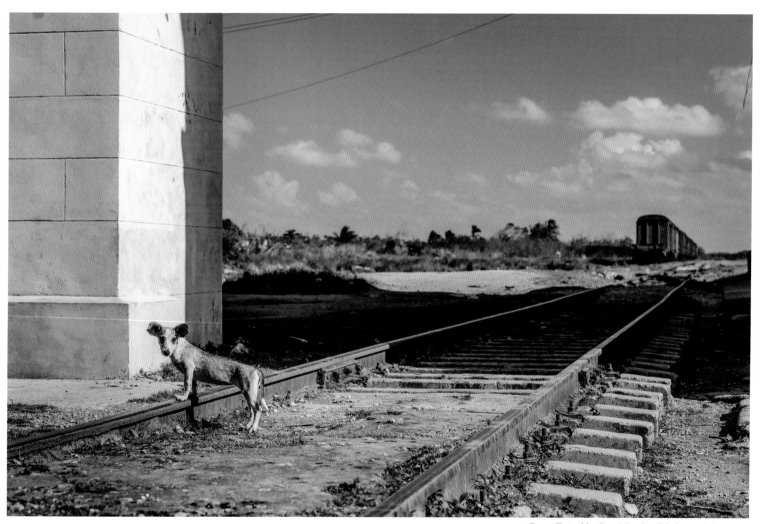

Cora, Estación San Martín, Cárdenas, Matanzas

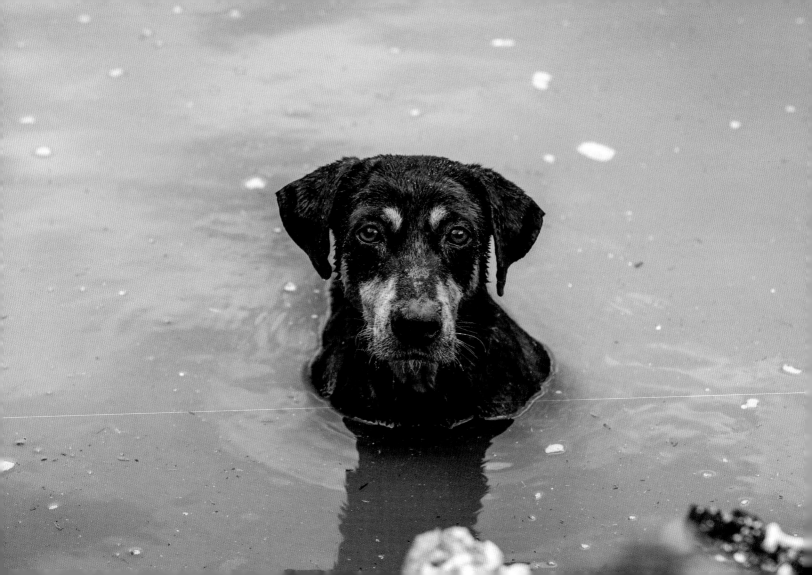

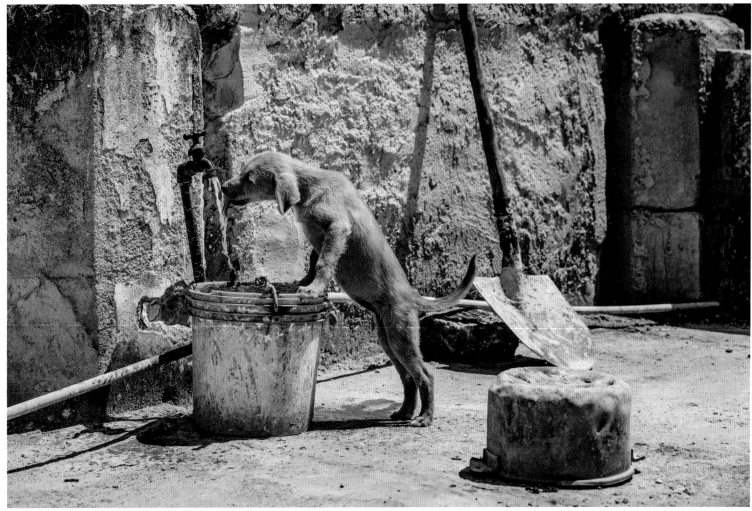

Eleko, Cárdenas, Matanzas

Miel, All People for Animals in Cuba (APAC), Cárdenas, Matanzas

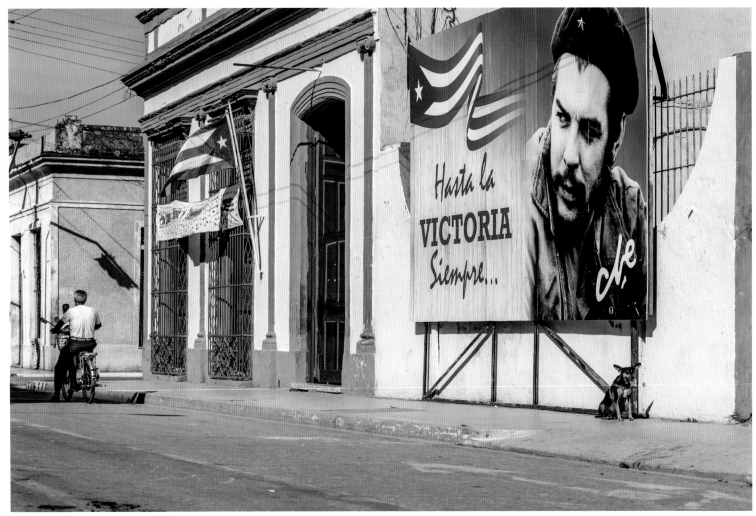

Doby, All People for Animals in Cuba (APAC), May Day, Cárdenas, Matanzas

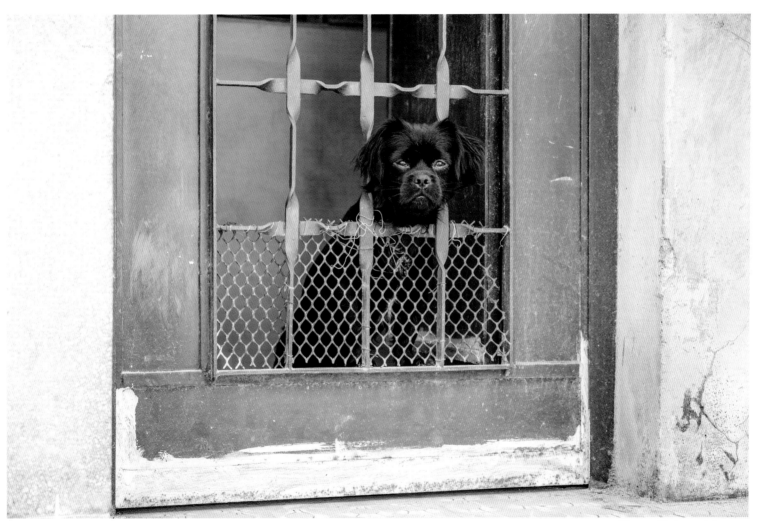

Floppy, Cárdenas, Matanzas

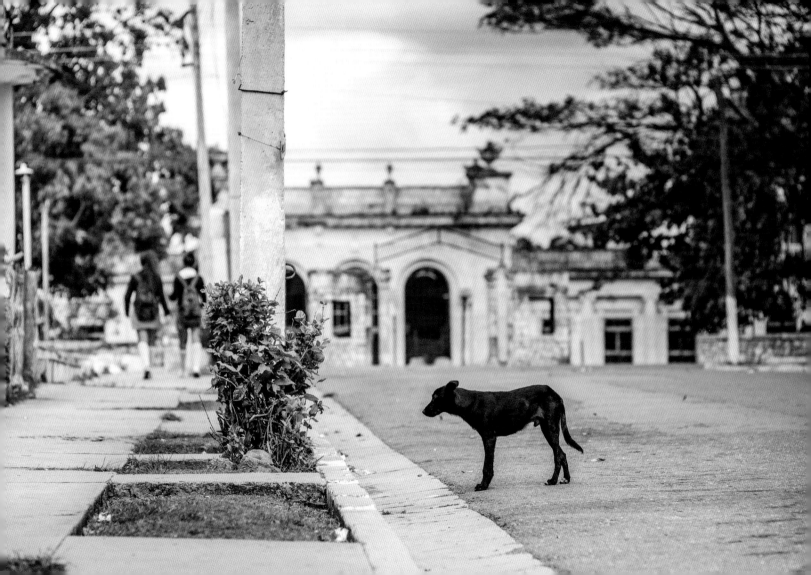

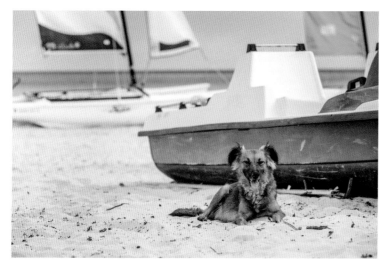

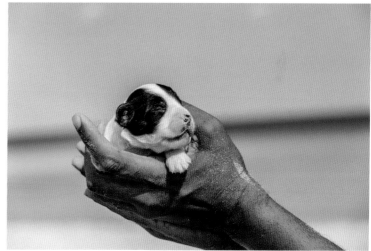

San Miguel de los Baños, Matanzas

All People for Animals in Cuba (APAC), Varadero, Matanzas

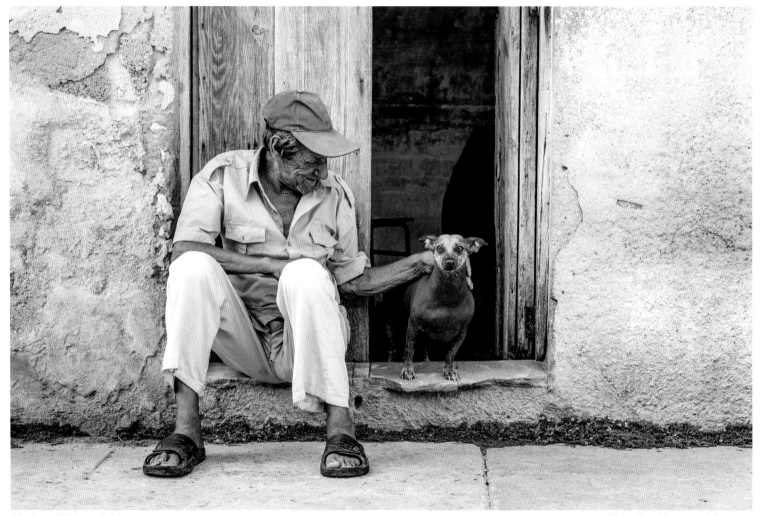

Marissa, Cárdenas, Matanzas

Versalles, Matanzas, Matanzas

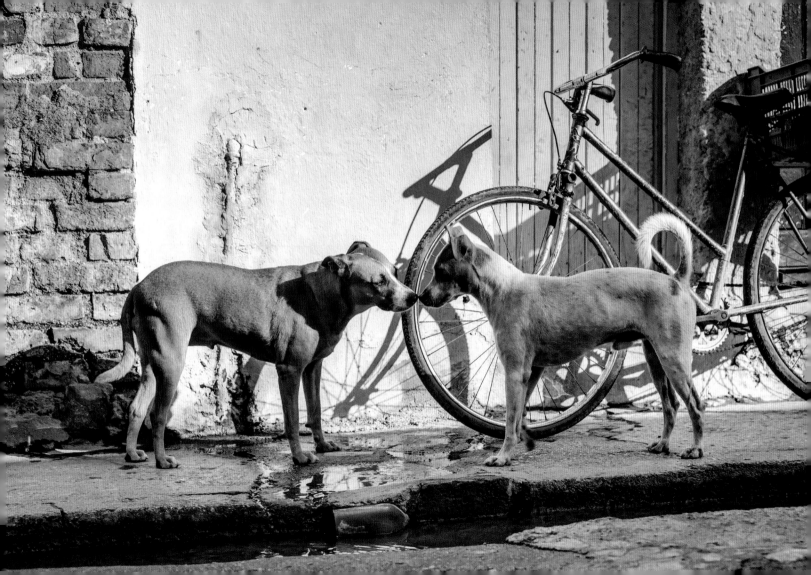

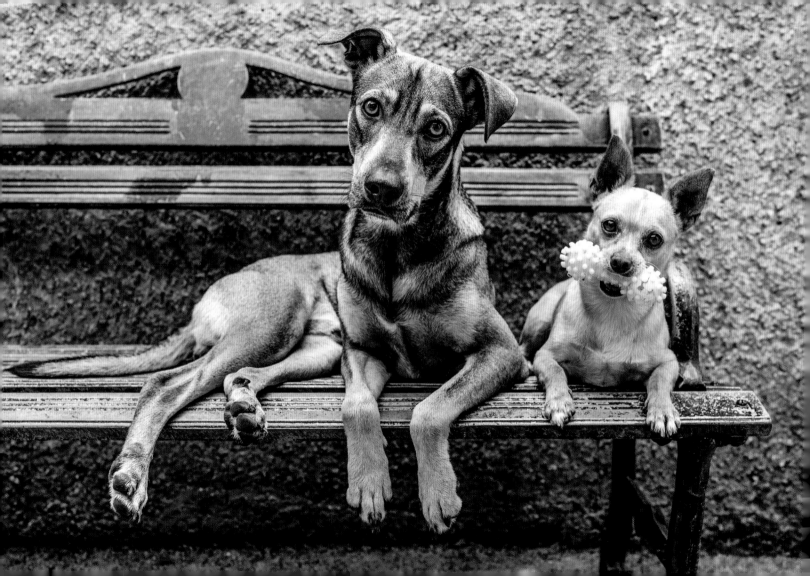

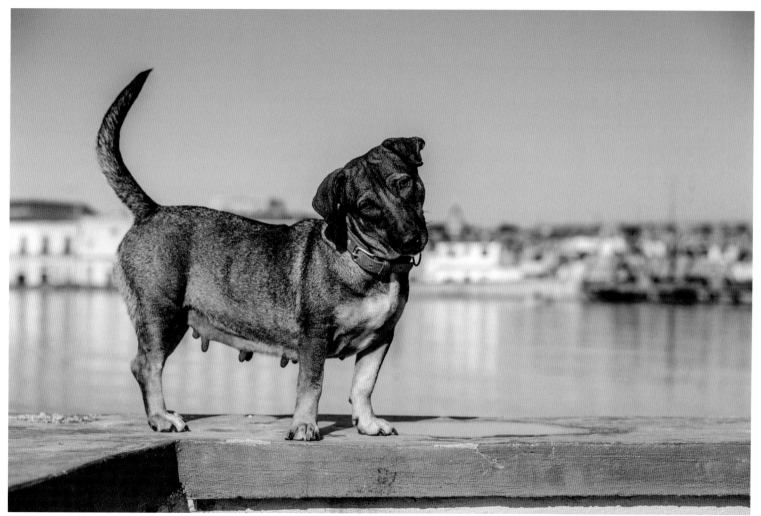

Picasso y Hendrix, Los Mangos, Matanzas, Matanzas

Bolita, Parque El Chiquirrín, Versalles, Matanzas, Matanzas

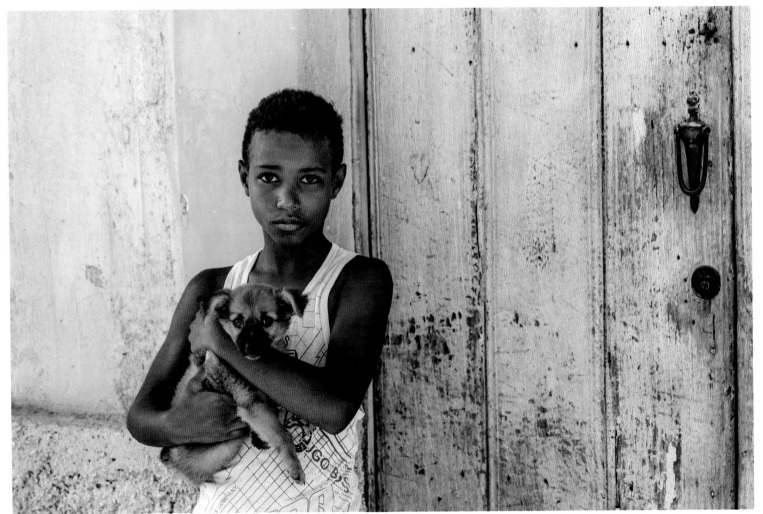

Versalles, Matanzas, Matanzas

Río San Juan, Matanzas, Matanzas

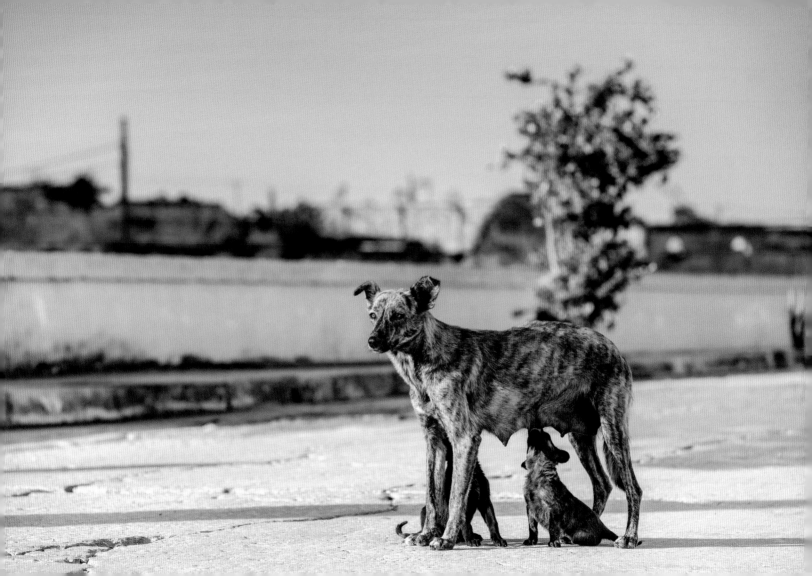

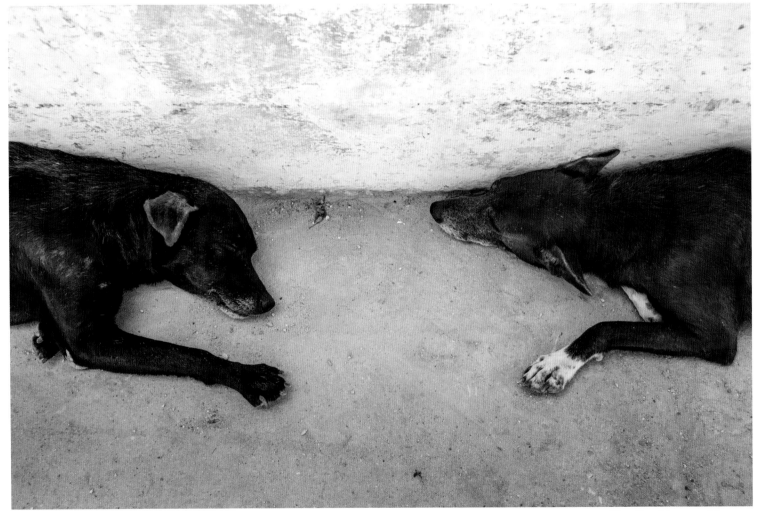

Negro y Negra, Río San Juan, Matanzas, Matanzas

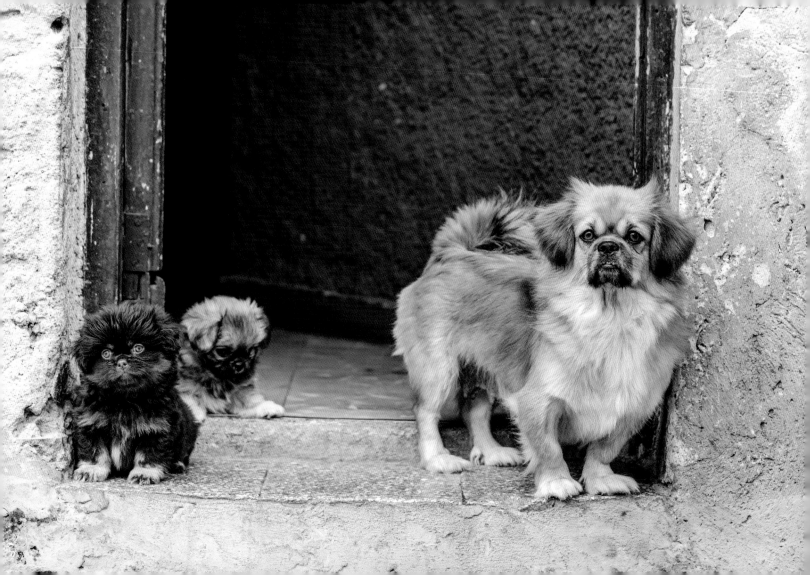

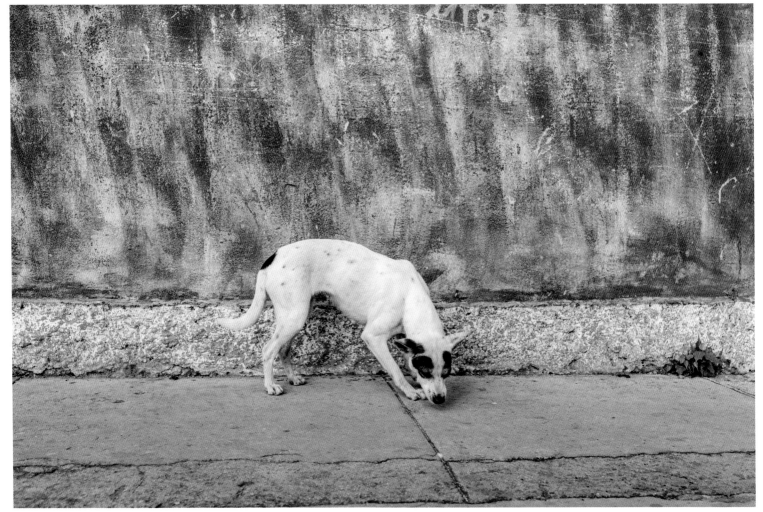

Versalles, Matanzas, Matanzas

Los Mangos, Matanzas, Matanzas

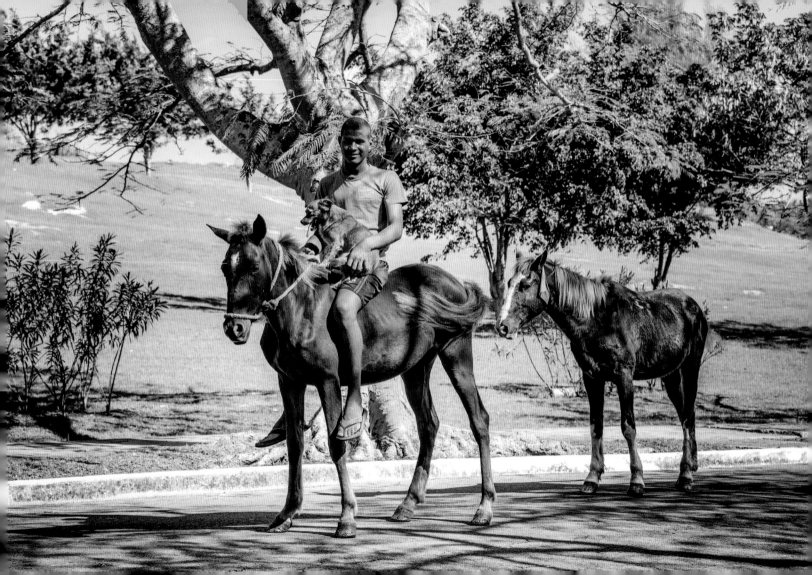

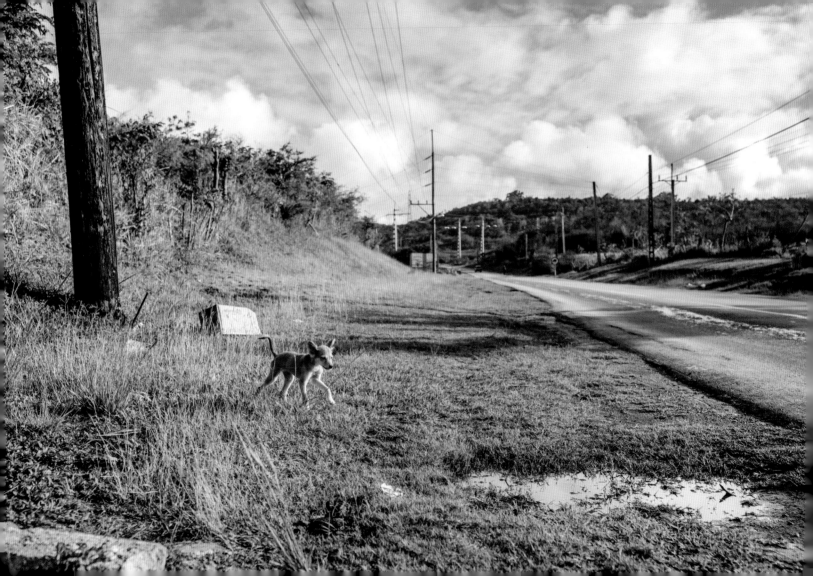

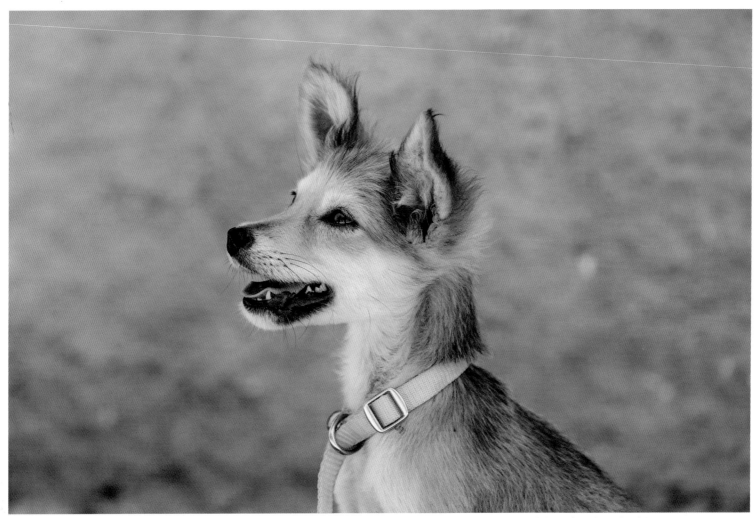

Santa Cruz del Norte, Mayabeque

Bamby, Dr. Viacheslav Eduardovich Zenkov (veterinario), Matanzas, Matanzas

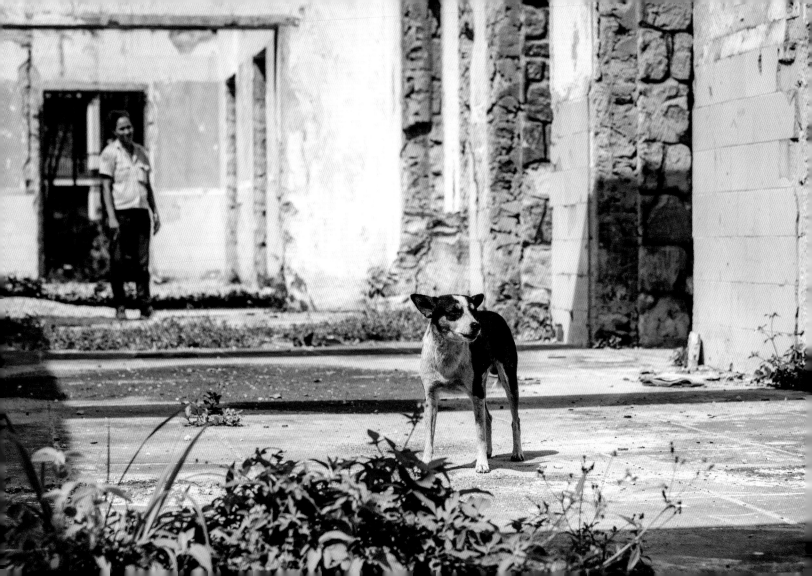

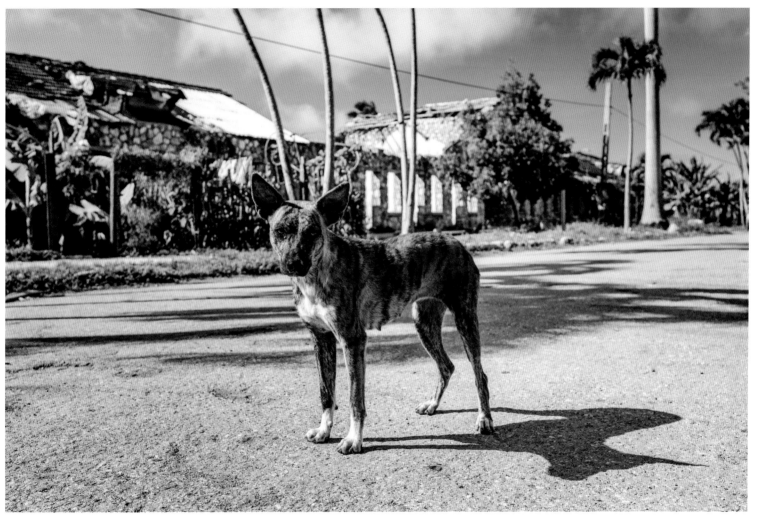

Pinti, Camilo Cienfuegos (Hershey), Mayabeque *Vanesa*, Camilo Cienfuegos (Hershey), Mayabeque

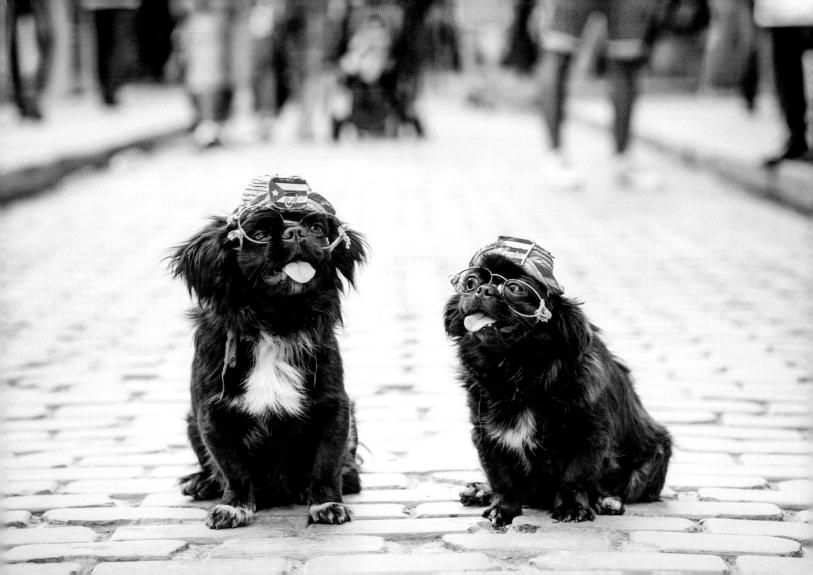

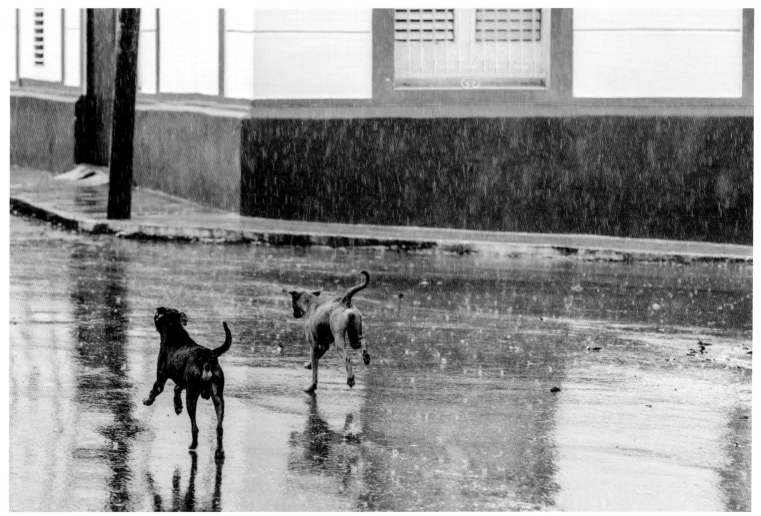

Habana Vieja, La Habana

Casablanca, La Habana

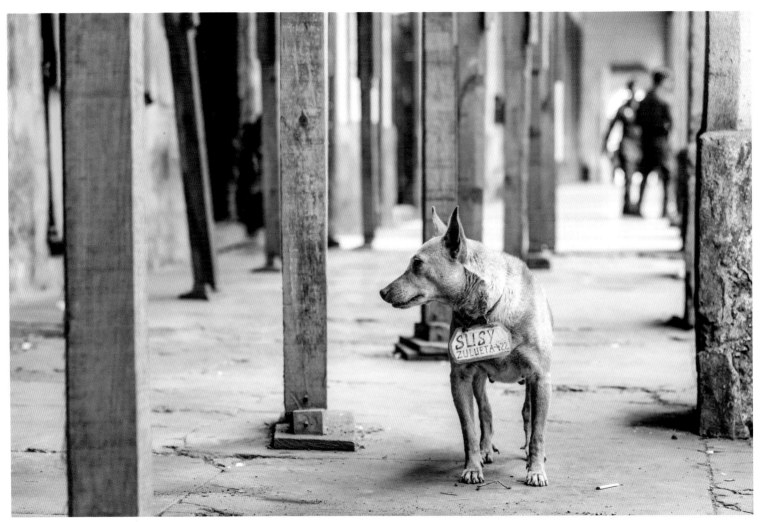

Susy, Habana Vieja, La Habana

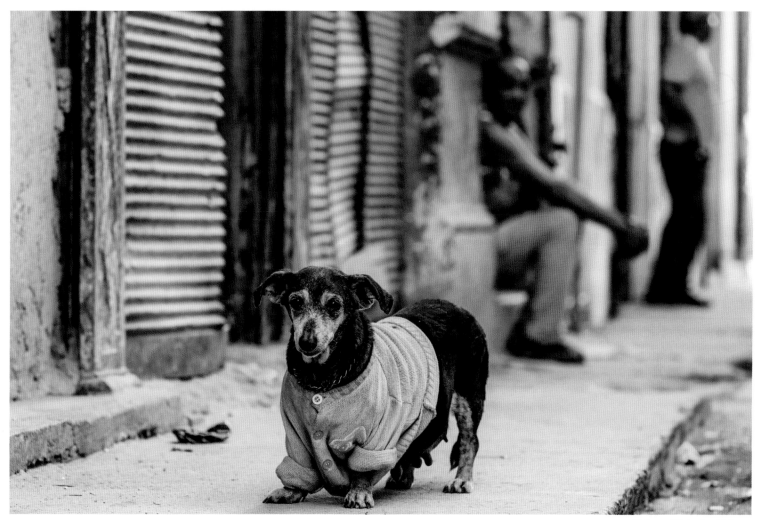

Habana Vieja, La Habana

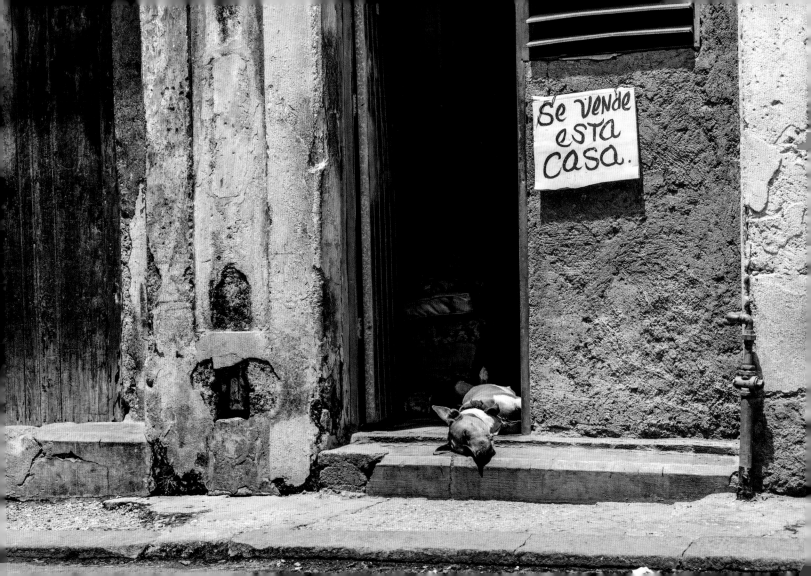

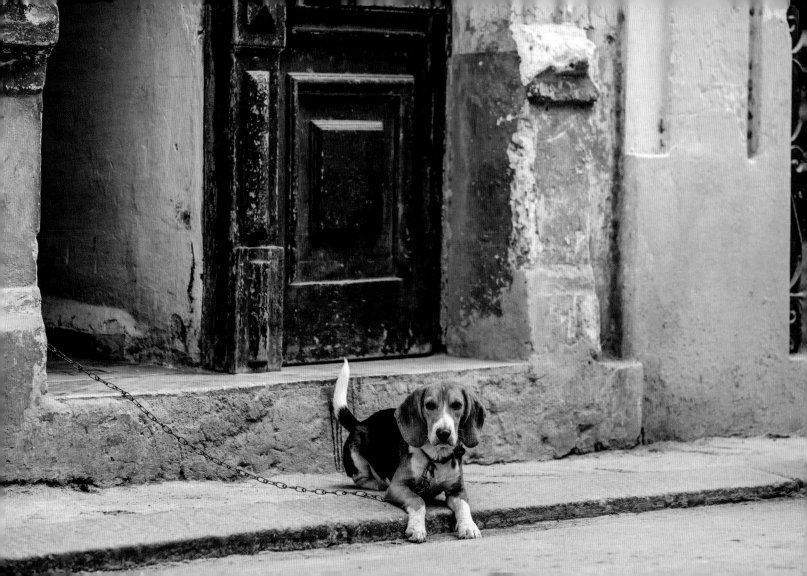

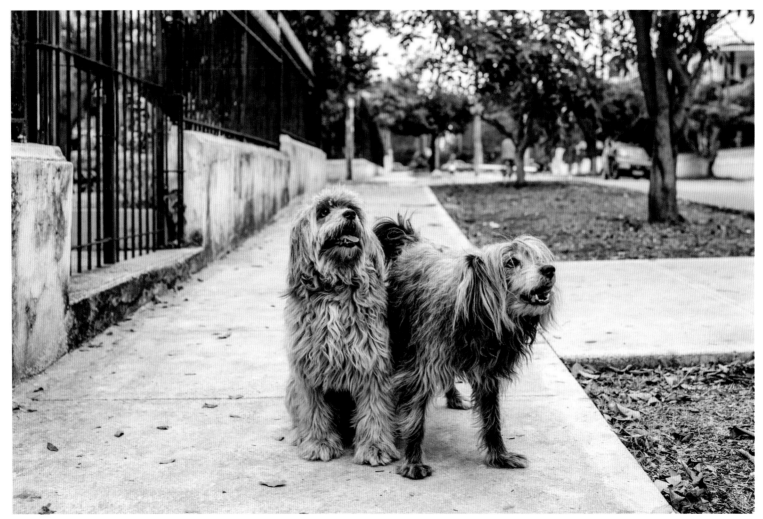

Princesa y Chito, Vedado, La Habana

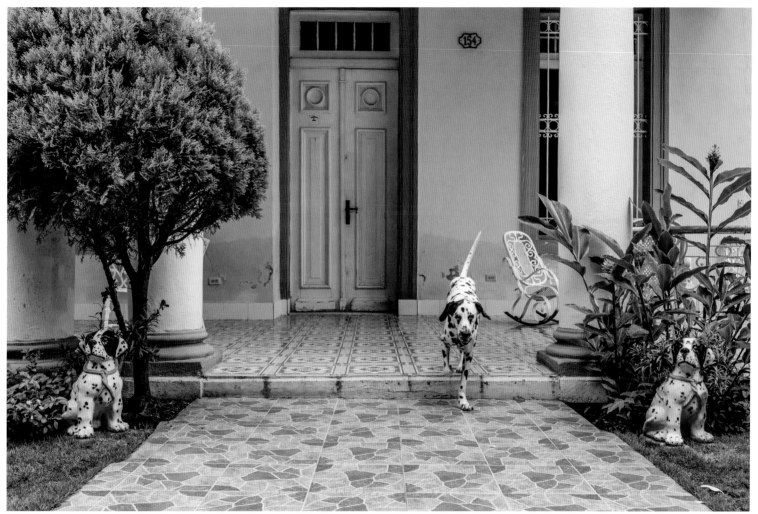

Momo, Vedado, La Habana

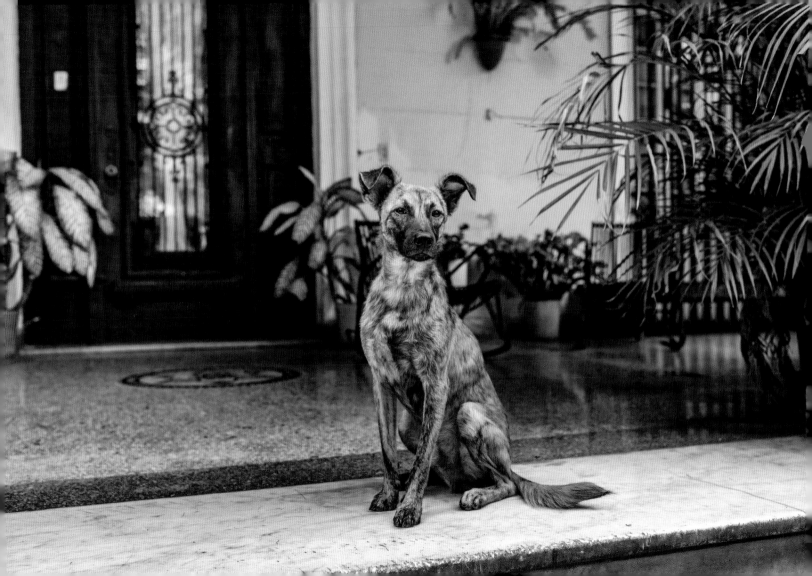

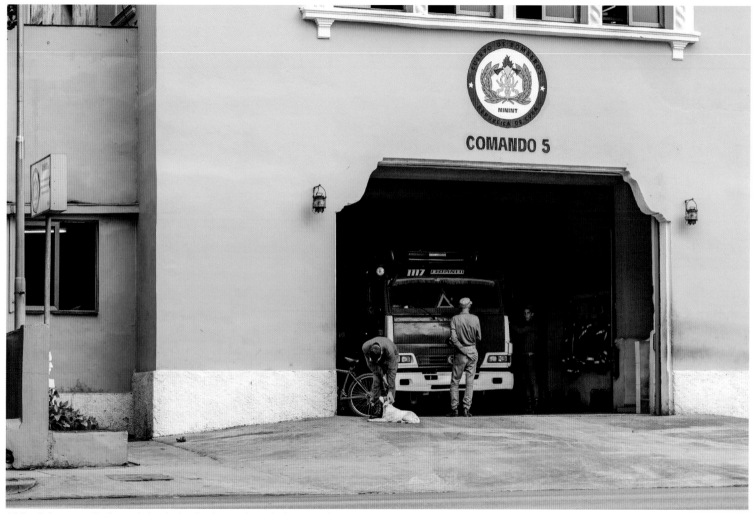

Melo, Cubanos en Defensa de los Animales (CEDA), Vedado, La Habana

Blanquita, Bomberos de Comando 5, Vedado, La Habana

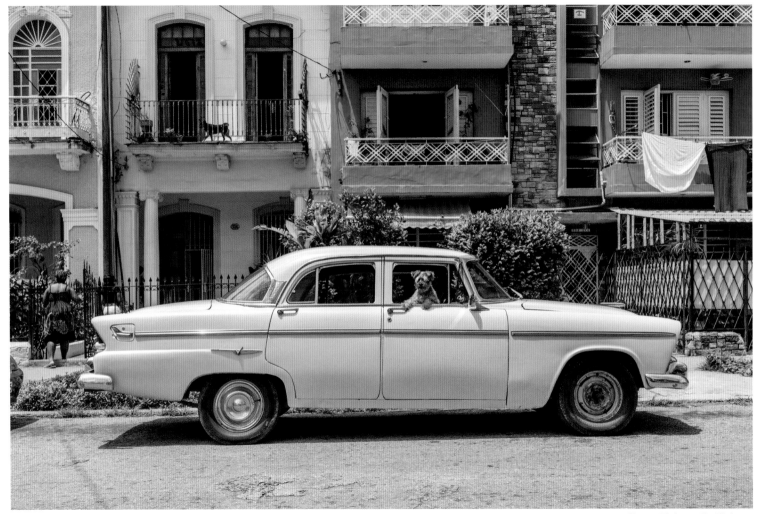

Lola, Vedado, La Habana

Centro Habana, La Habana

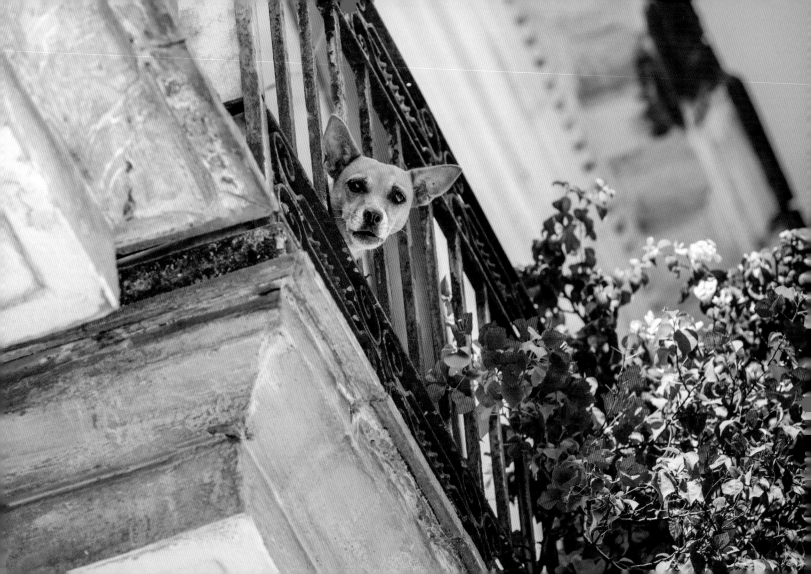

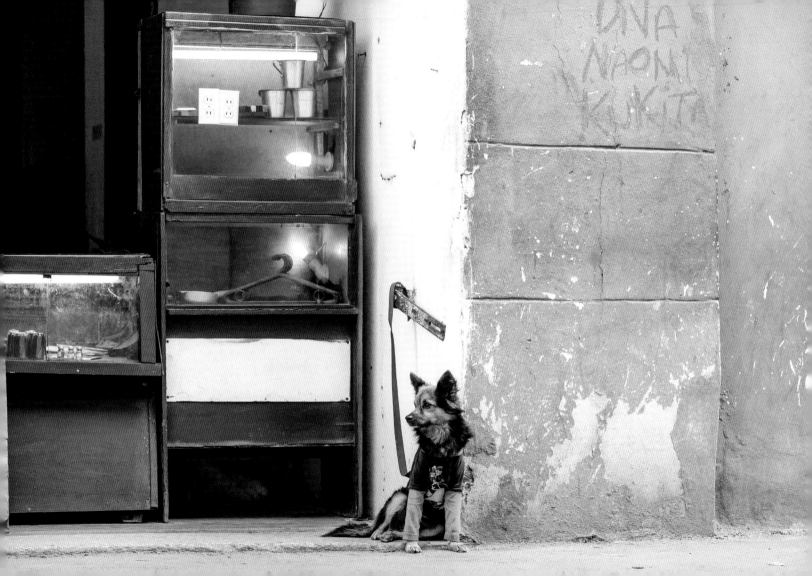

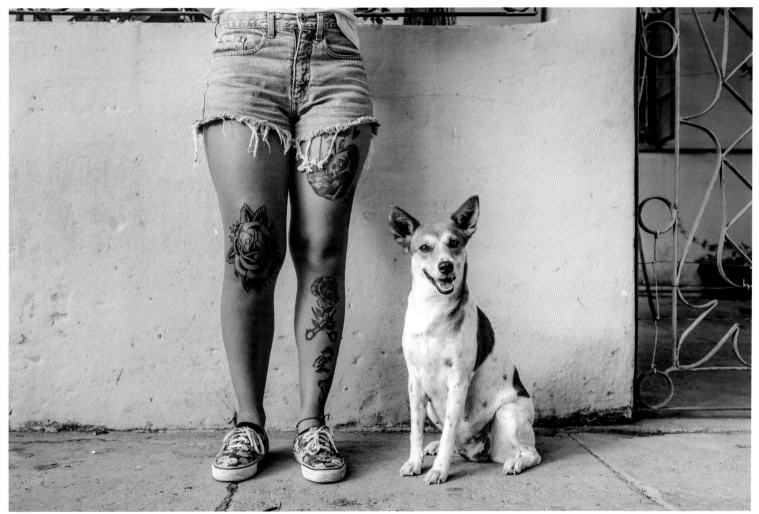

Chuky, Centro Habana, La Habana

Flaca, Cerro, La Habana

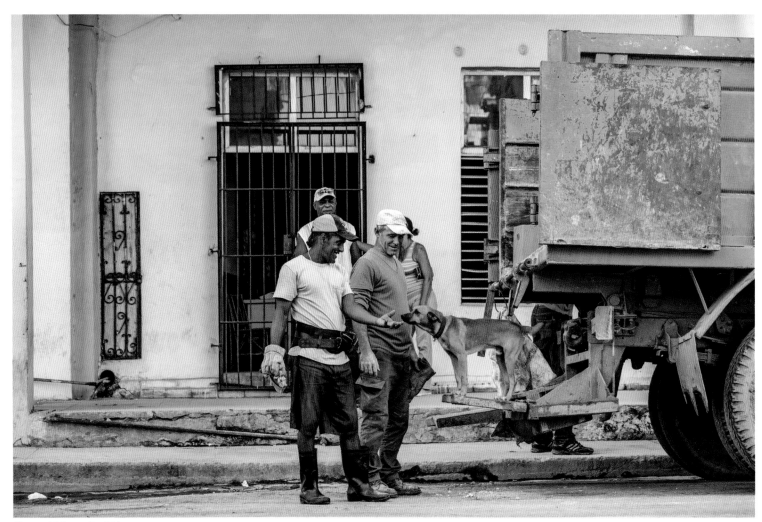

Centro Habana, La Habana

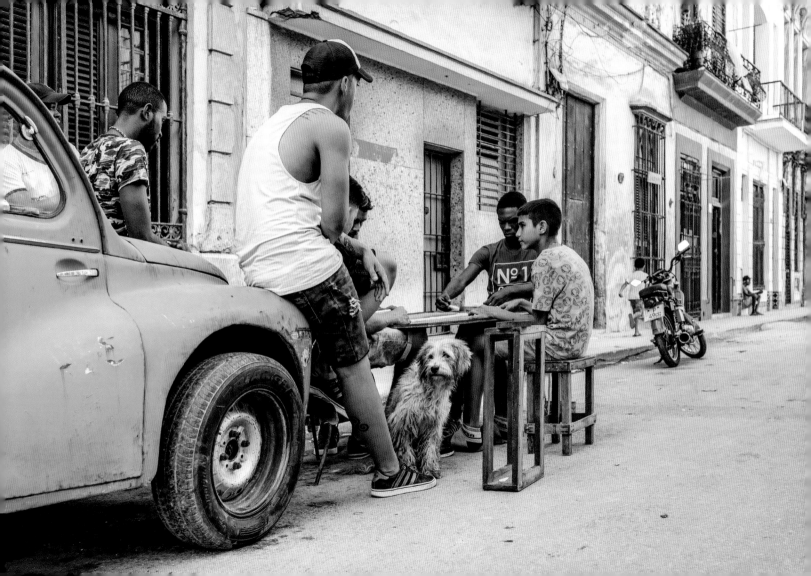

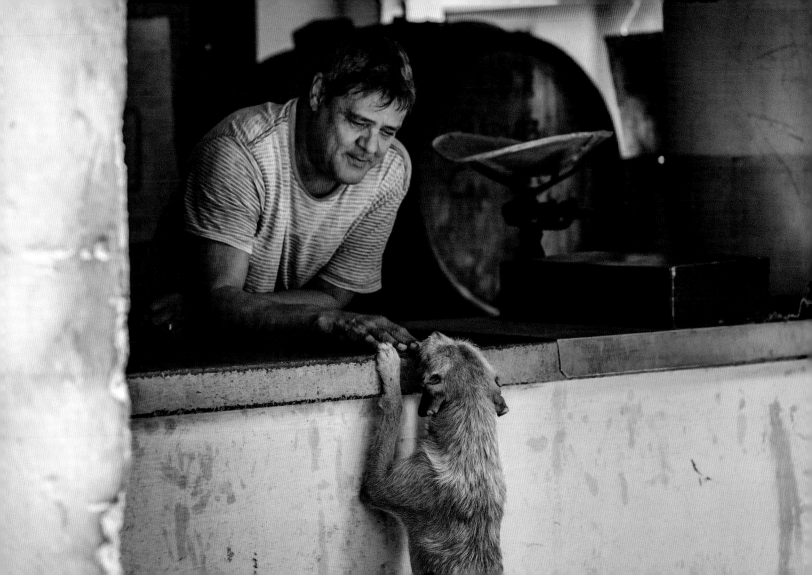

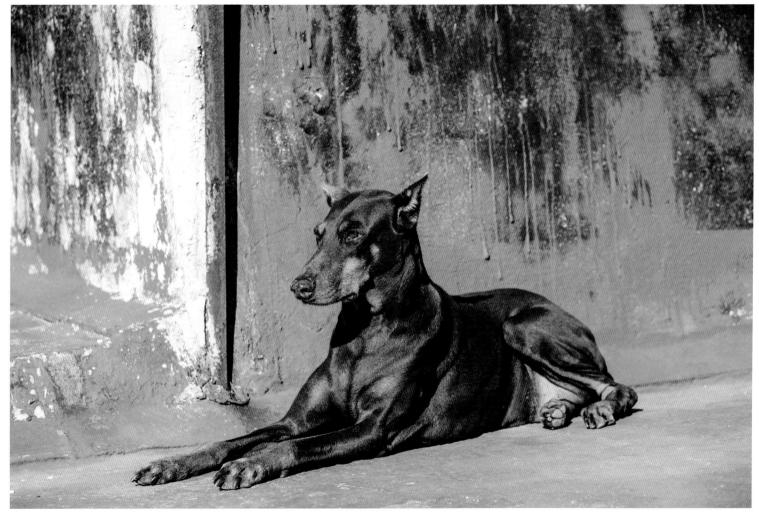

Centro Habana, La Habana

Laika, Centro Habana, La Habana

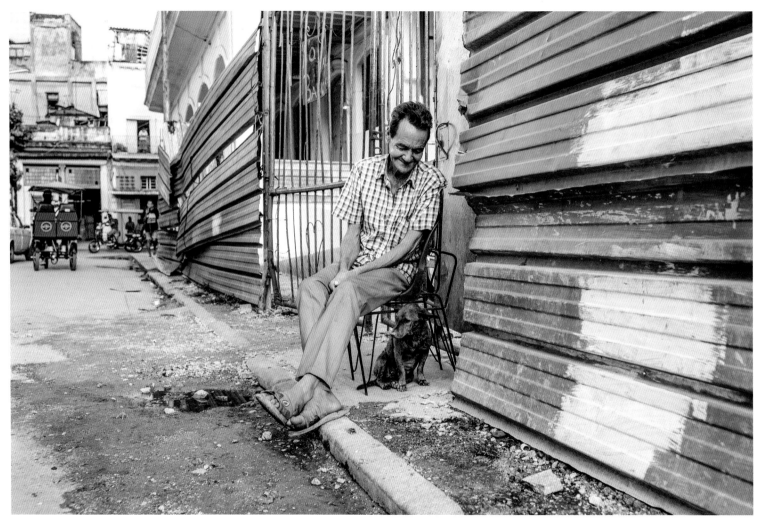

Habana Vieja, La Habana

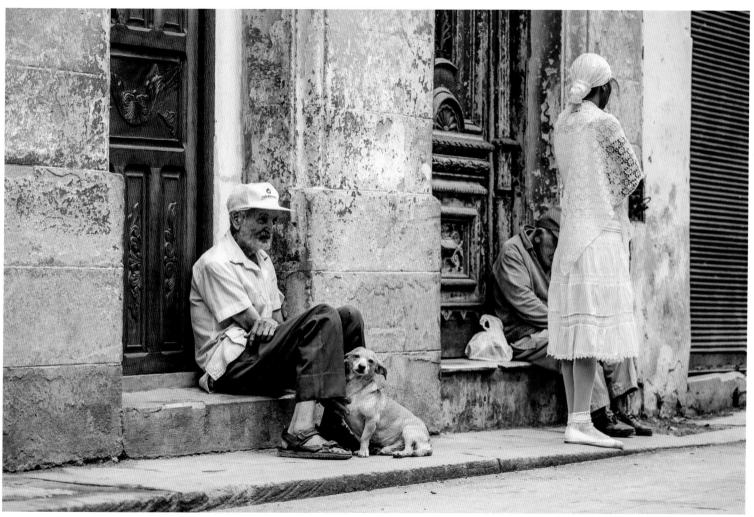

Habana Vieja, La Habana

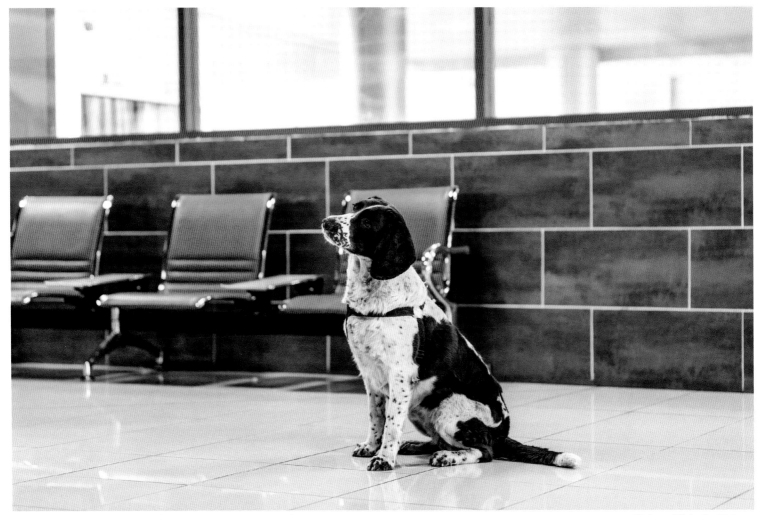

Jenny, Aeropuerto Internacional José Martí, Boyeros, La Habana

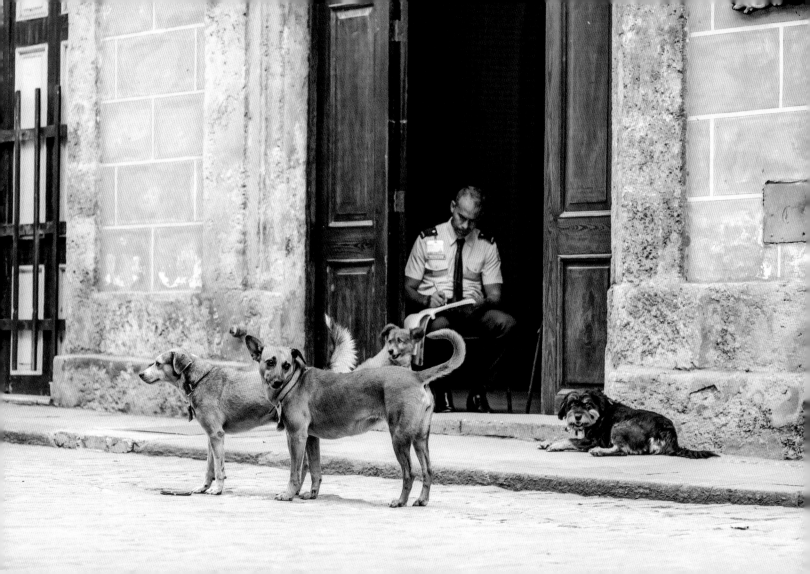

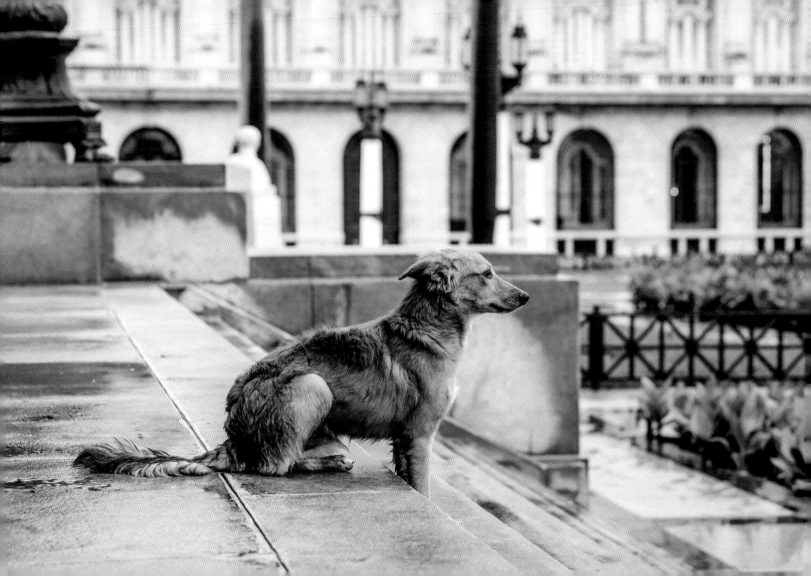

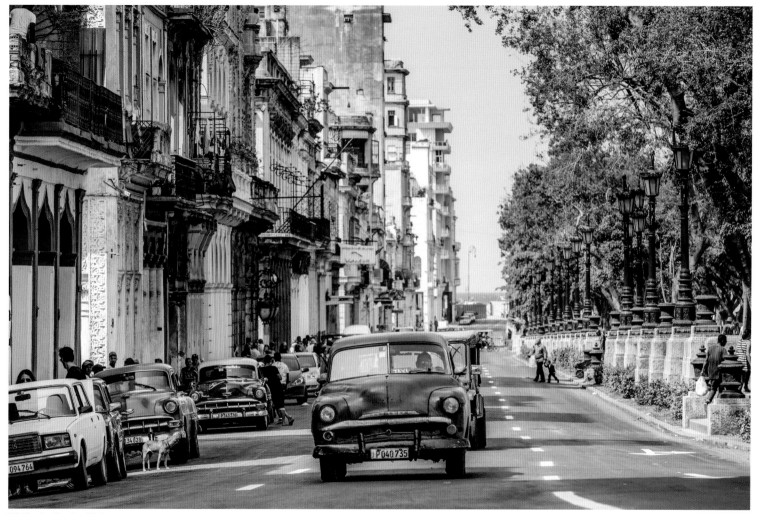

El Capitolio, La Habana

Paseo del Prado, La Habana

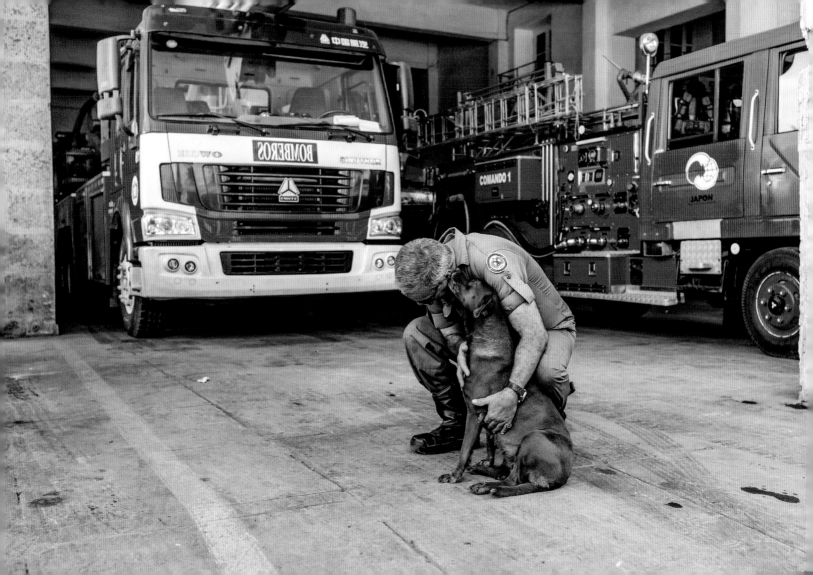

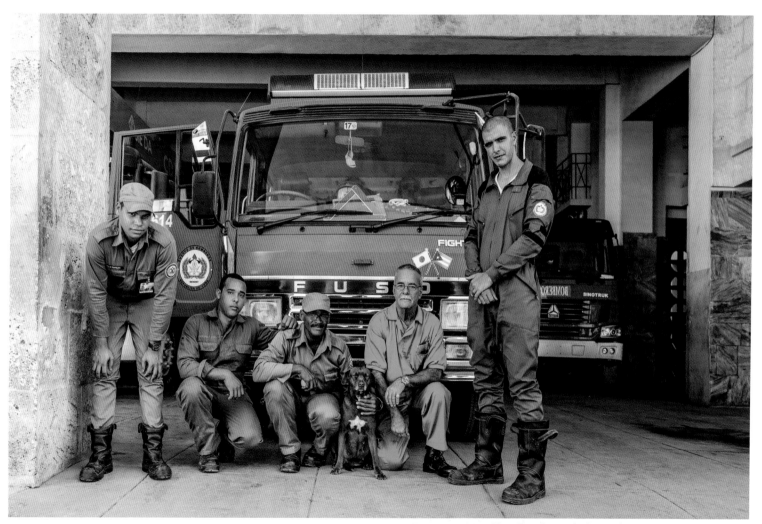

Niña, Bomberos de Comando 1, La Habana, La Habana

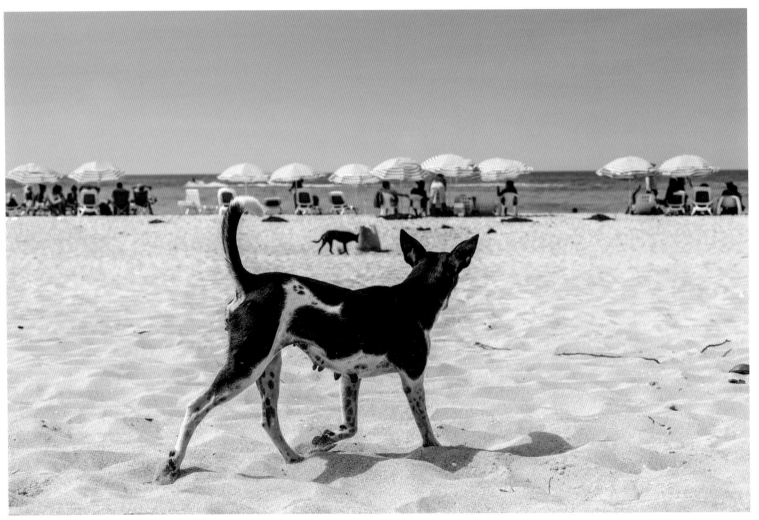

Tarará, La Habana

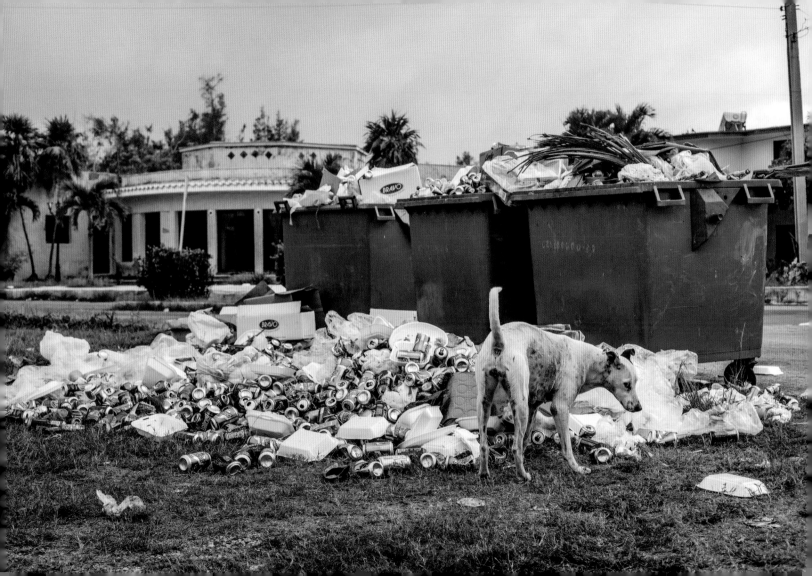

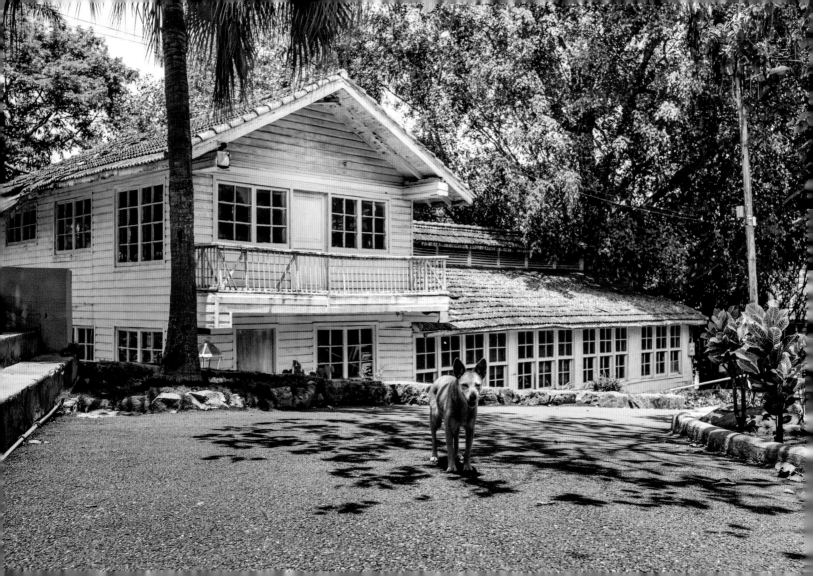

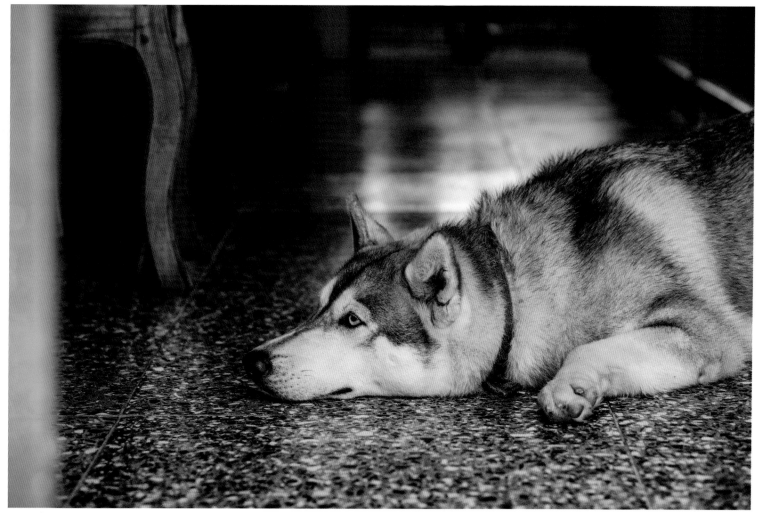

Fita, Finca Vigía de Ernest Hemingway, San Francisco de Paula, La Habana

Akira, Las Terrazas, Artemisa

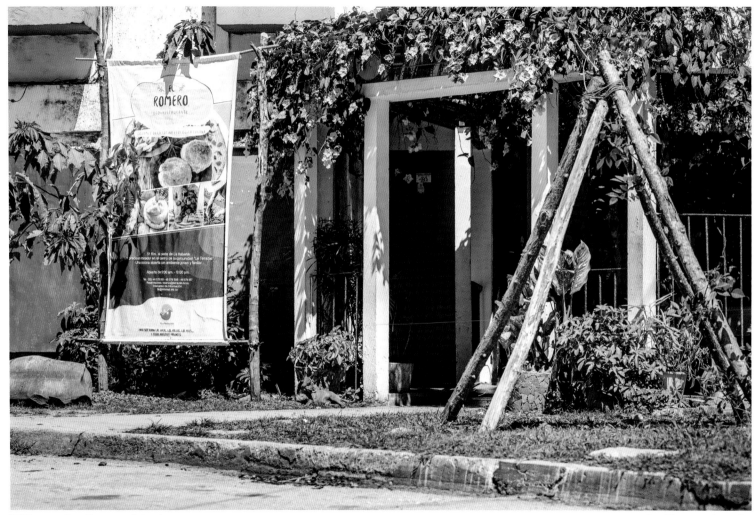

El Romero, Las Terrazas, Artemisa

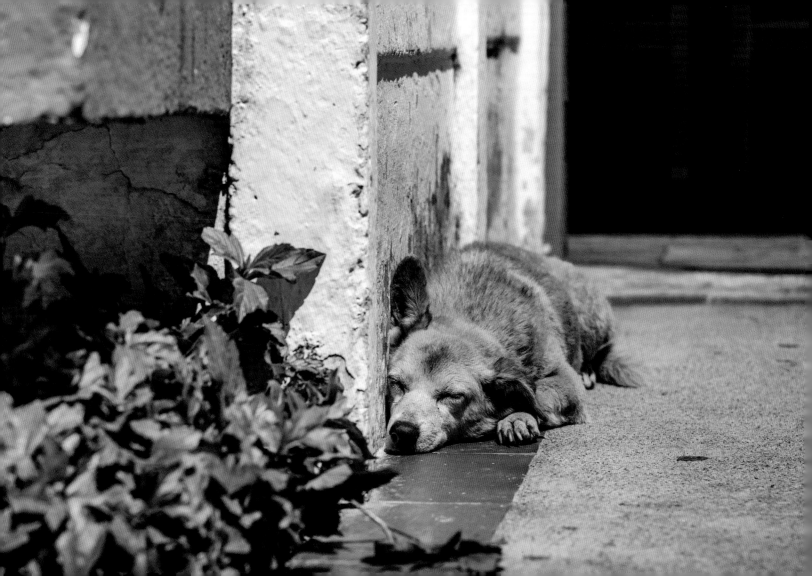

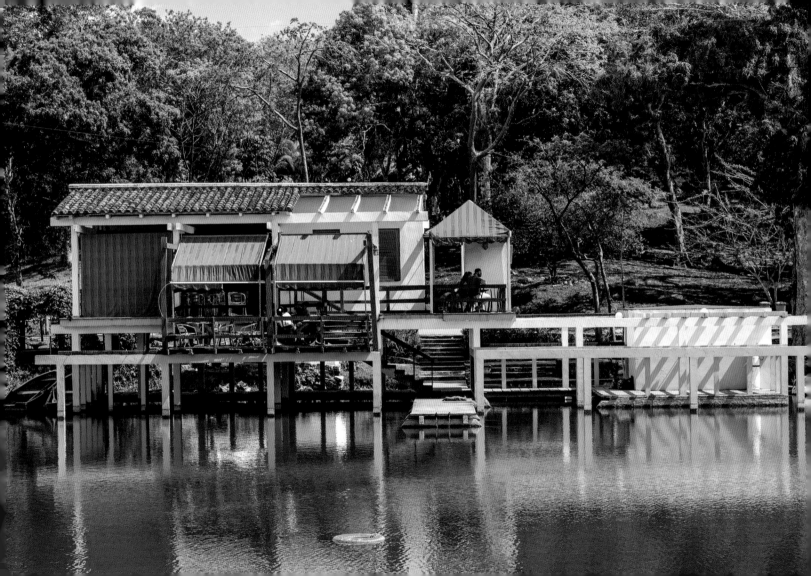

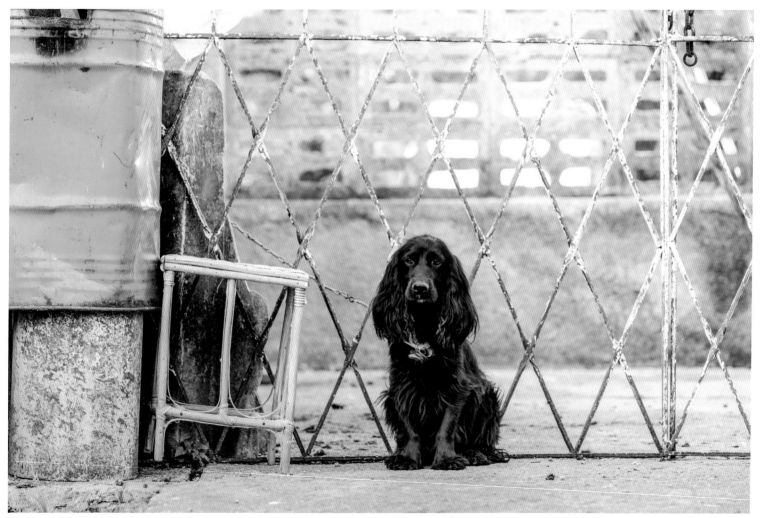

La Casa del Lago, Las Terrazas, Artemisa

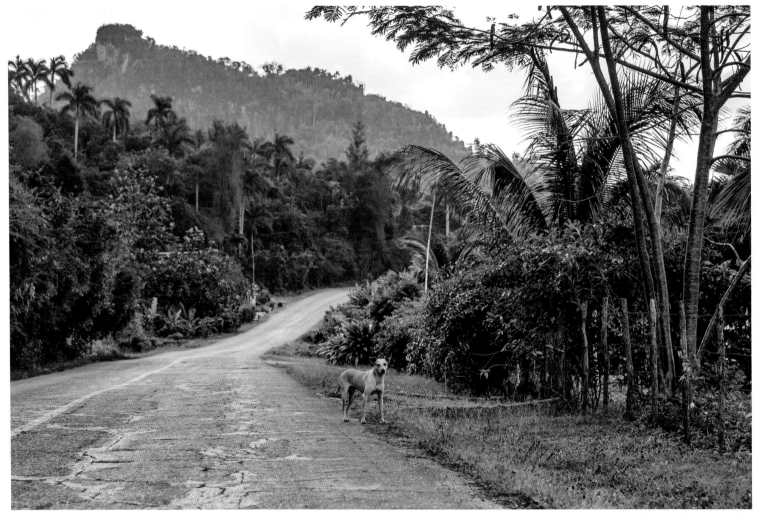

Soroa, Artemisa

Persea, Soroa, Artemisa

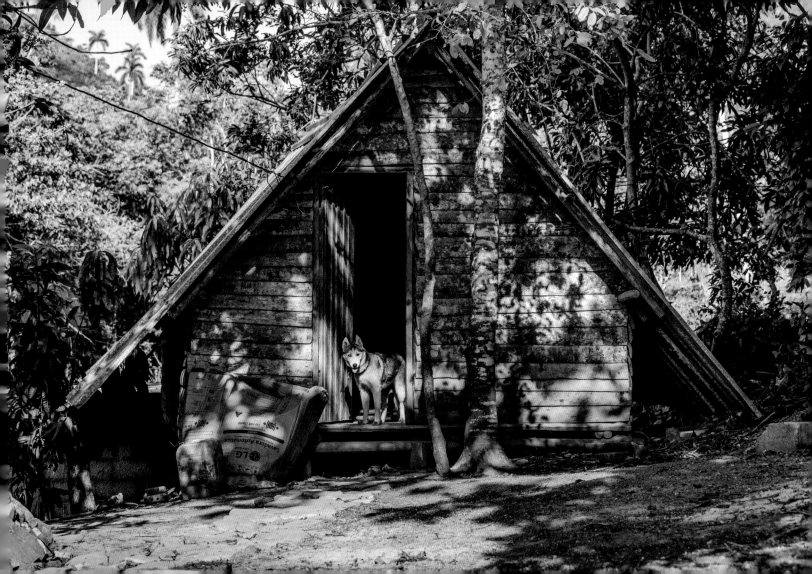

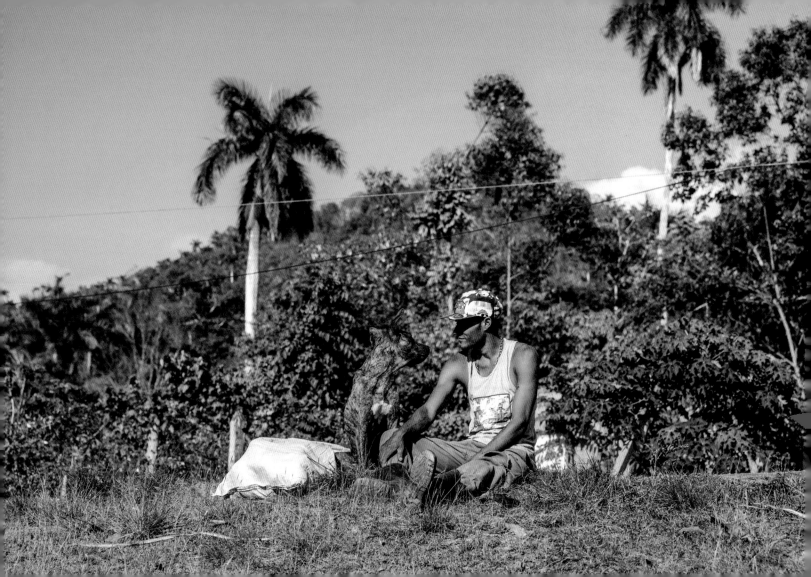

Kondo, Soroa, Artemisa

Niña, Castillo de las Nubes, Soroa, Artemisa

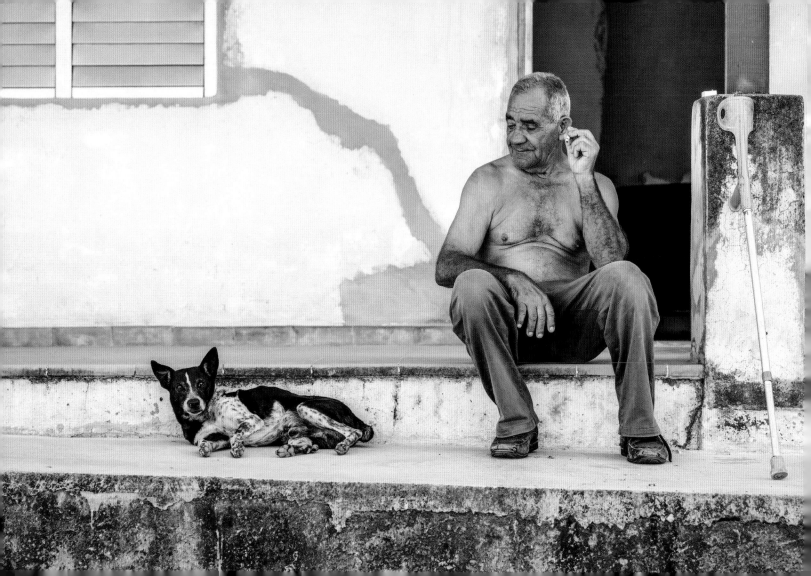

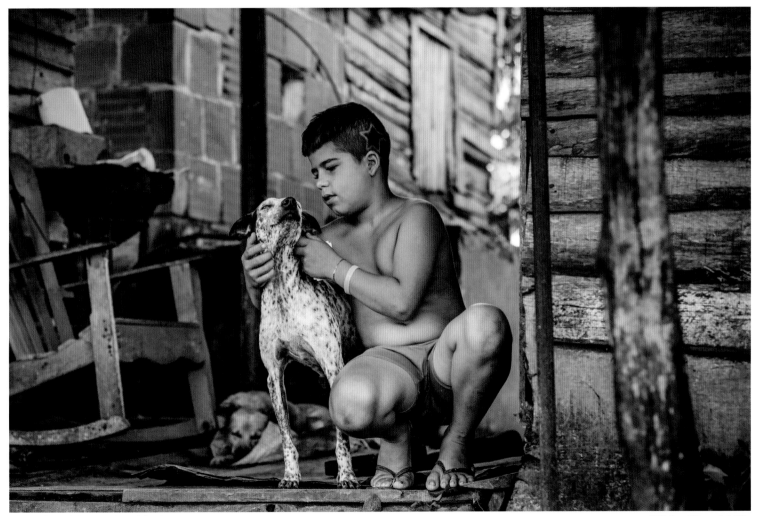

Sinfu, Pinar del Río, Pinar del Río

Viñales, Pinar del Río

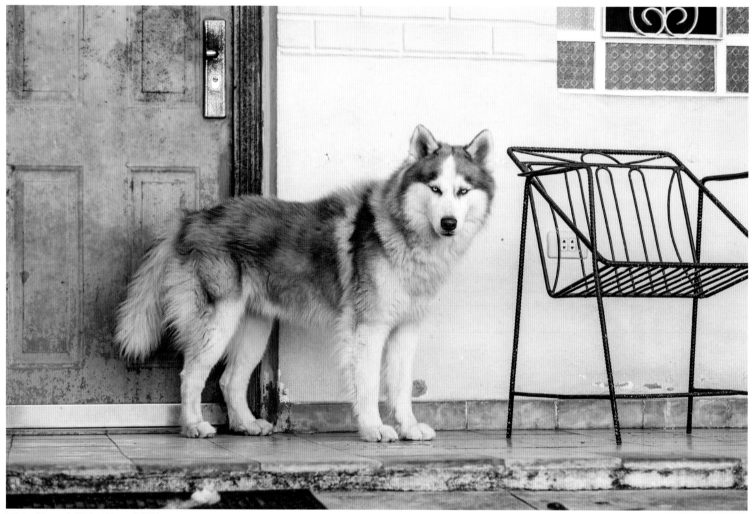

Klein, Pinar del Río, Pinar del Río

Viñales, Pinar del Río

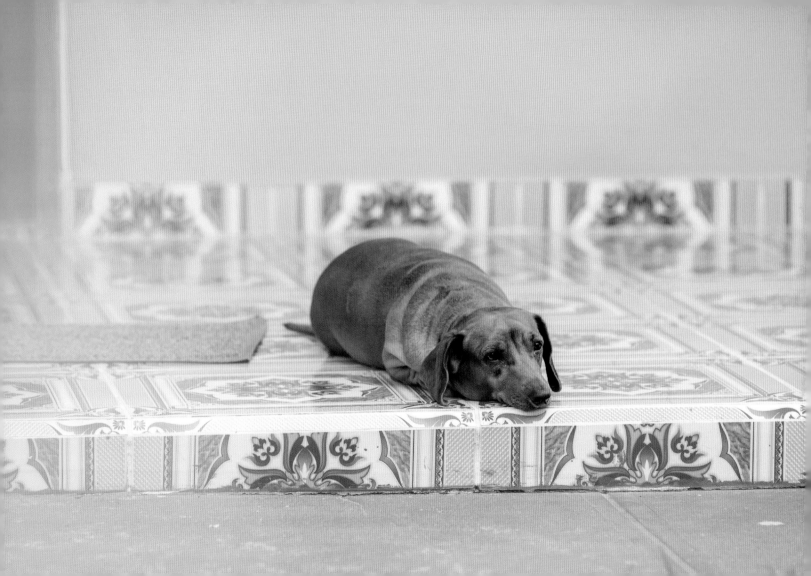

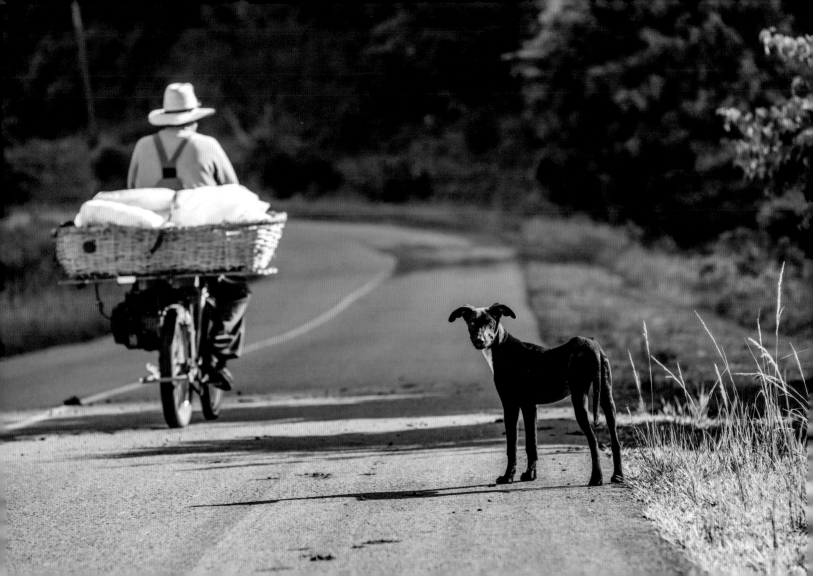

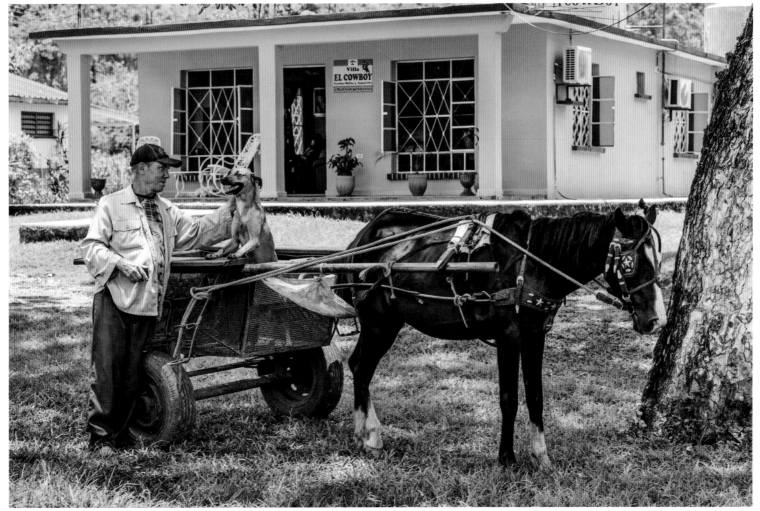

Viñales, Pinar del Río

Campeón, Viñales, Pinar del Río

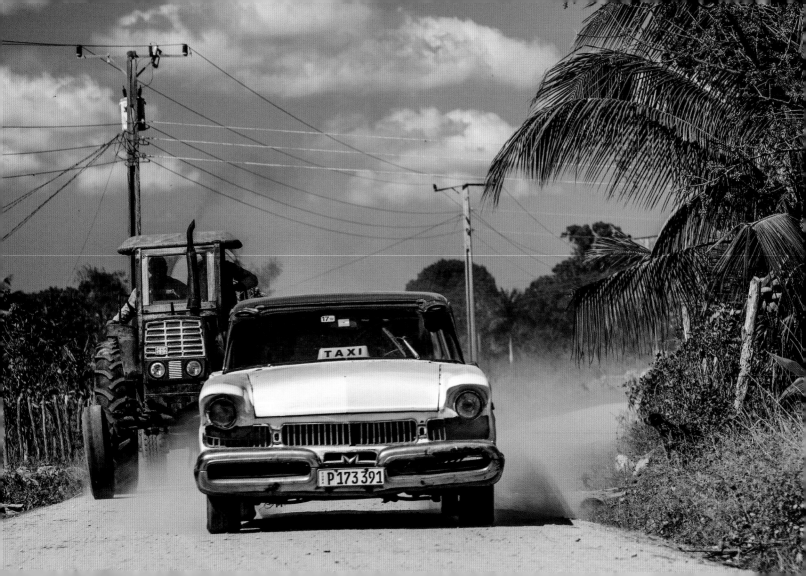

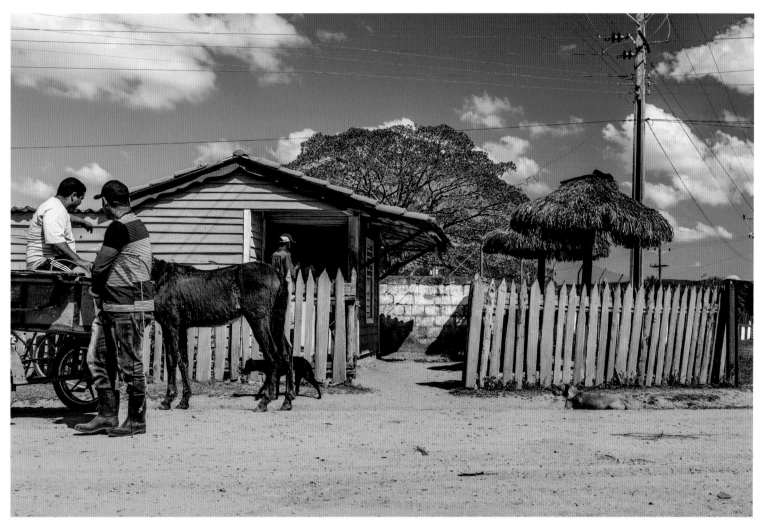

Los Pilotos, Pinar del Río

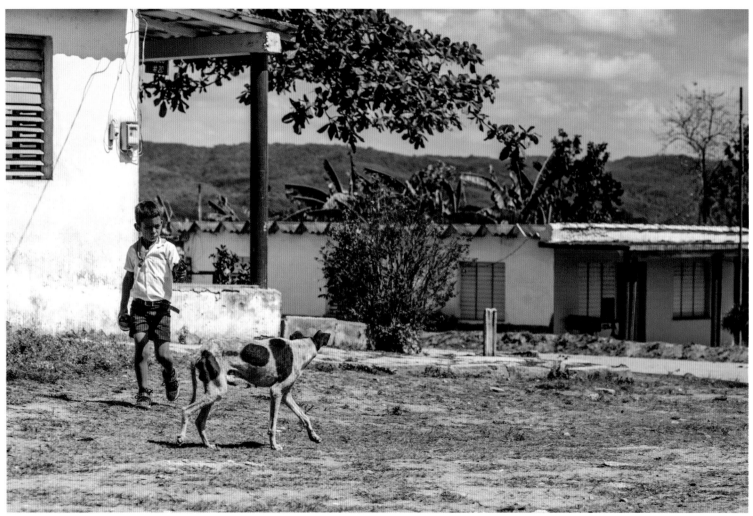

Los Pilotos, Pinar del Río

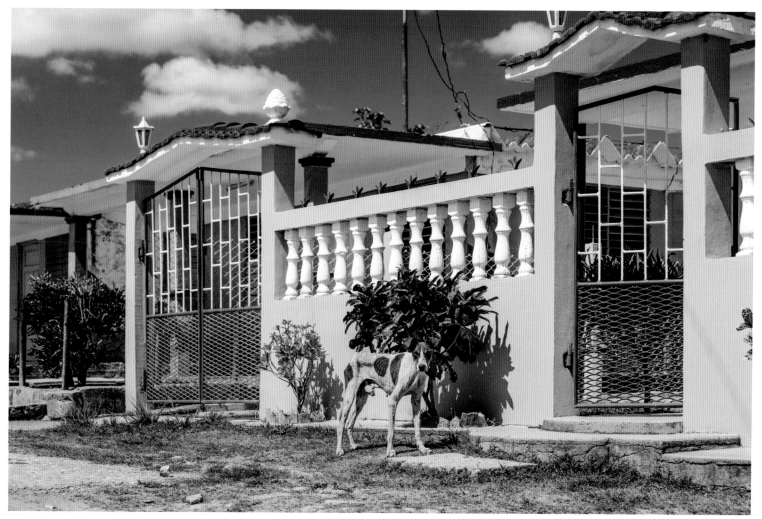

Los Pilotos, Pinar del Río

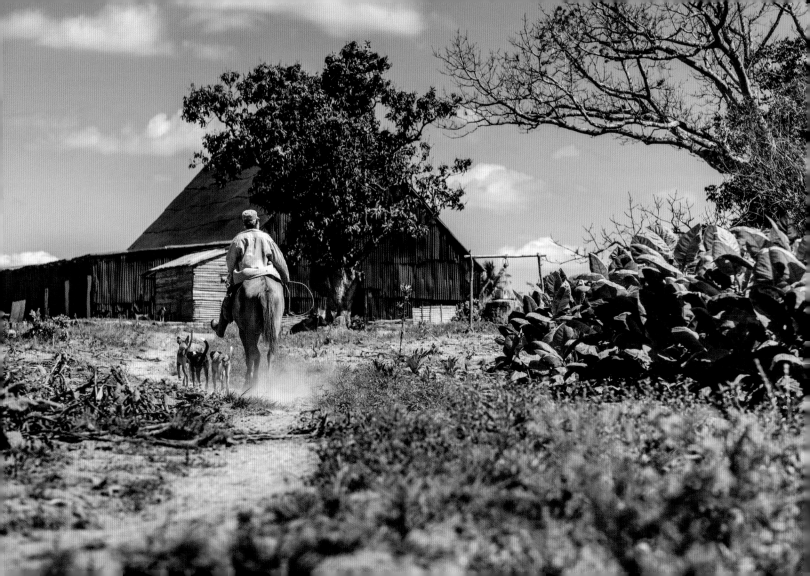

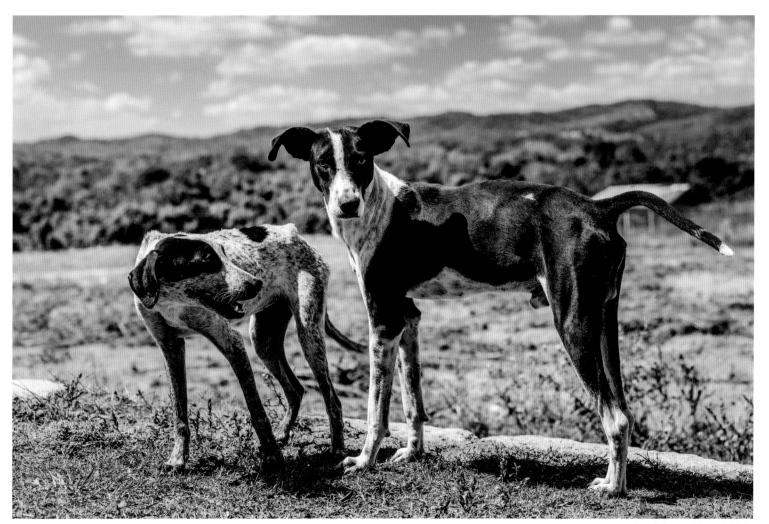

Los Pilotos, Pinar del Río

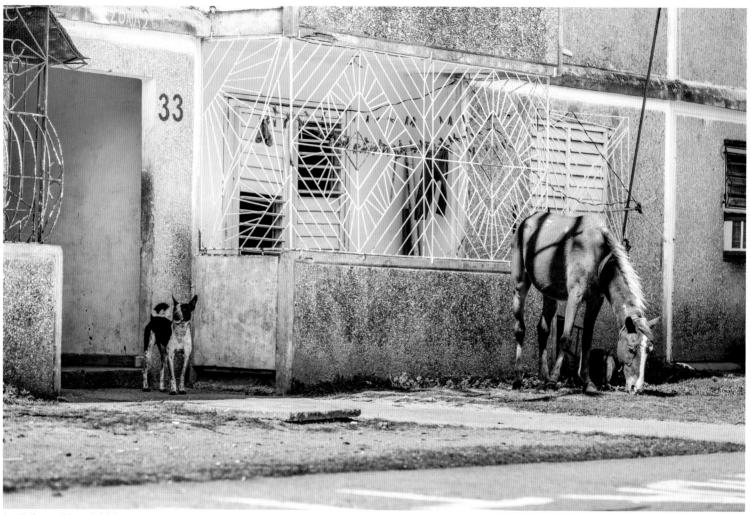

La Coloma, Pinar del Río

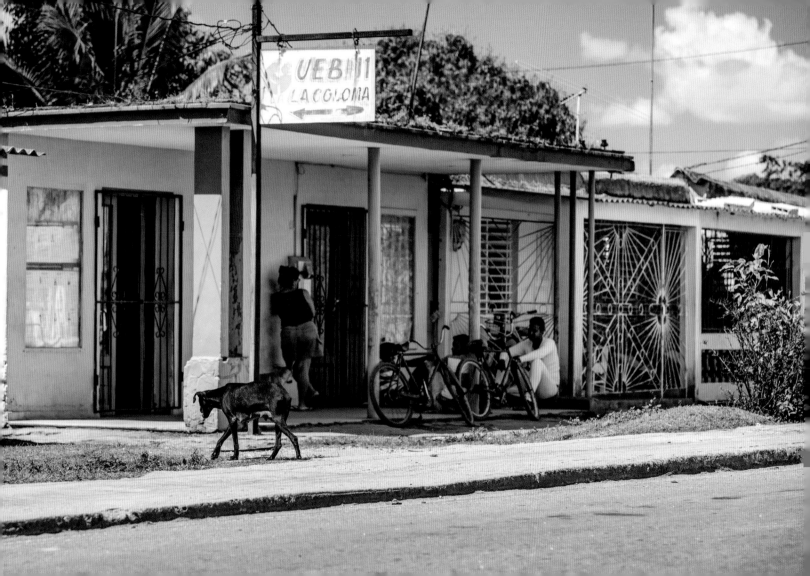

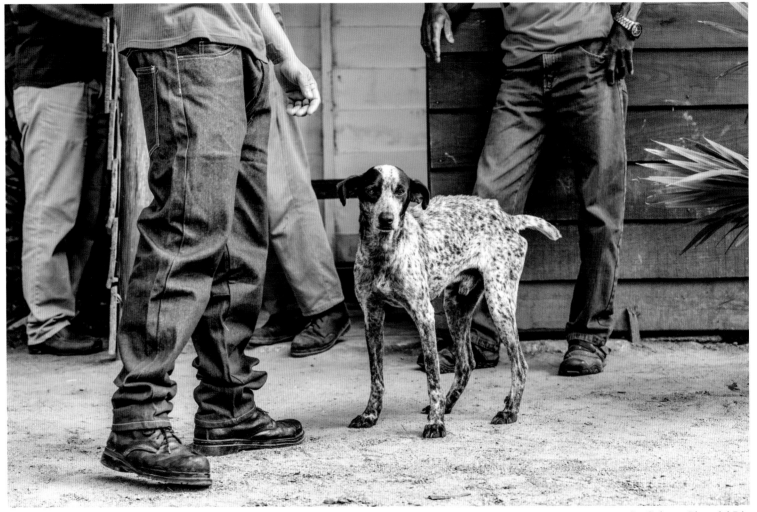

Mocho, La Coloma, Pinar del Río

La Coloma, Pinar del Río

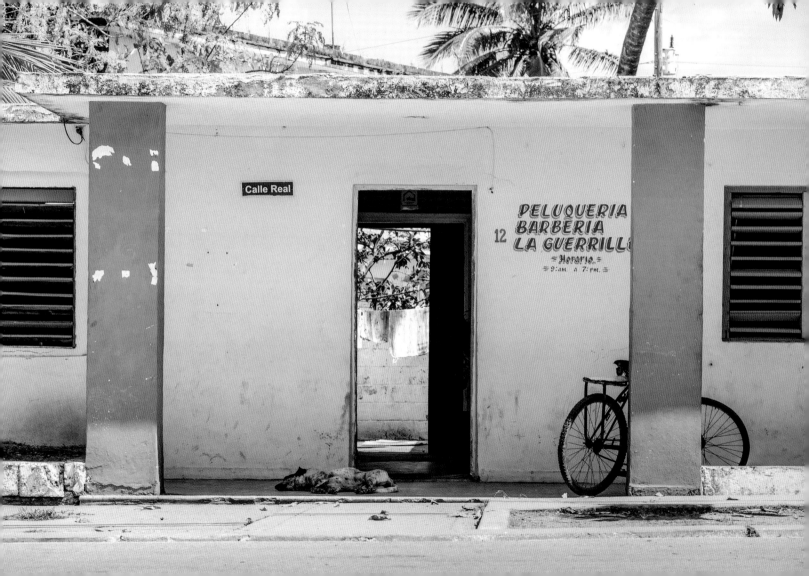

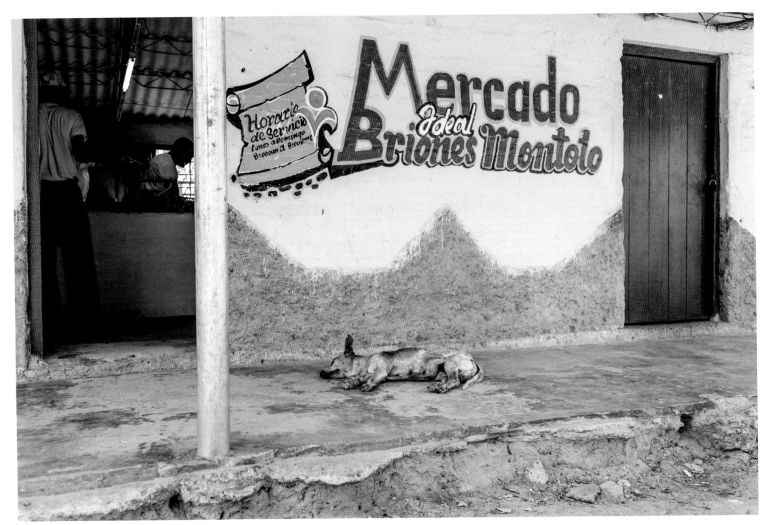

Briones Montoto, Pinar del Río

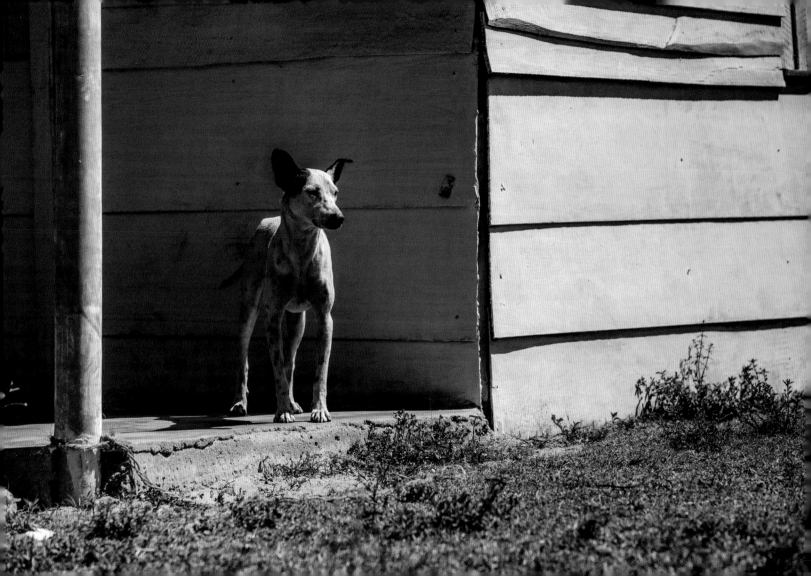

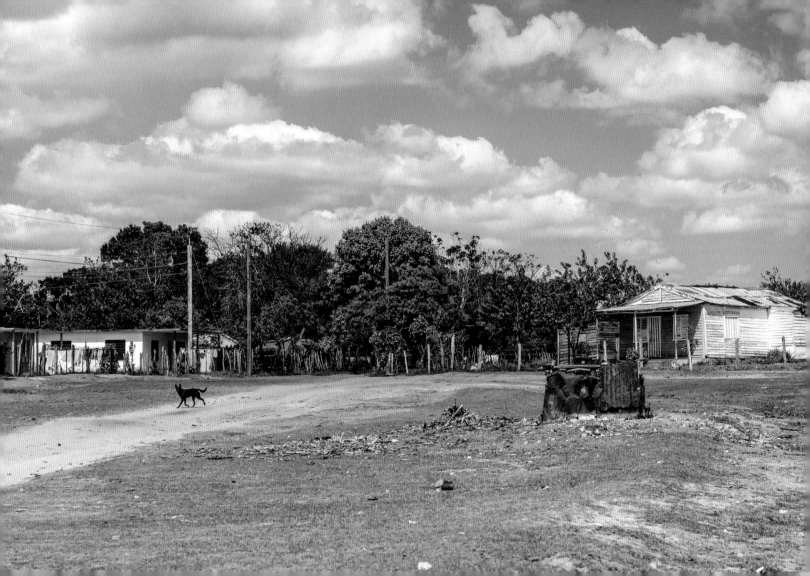

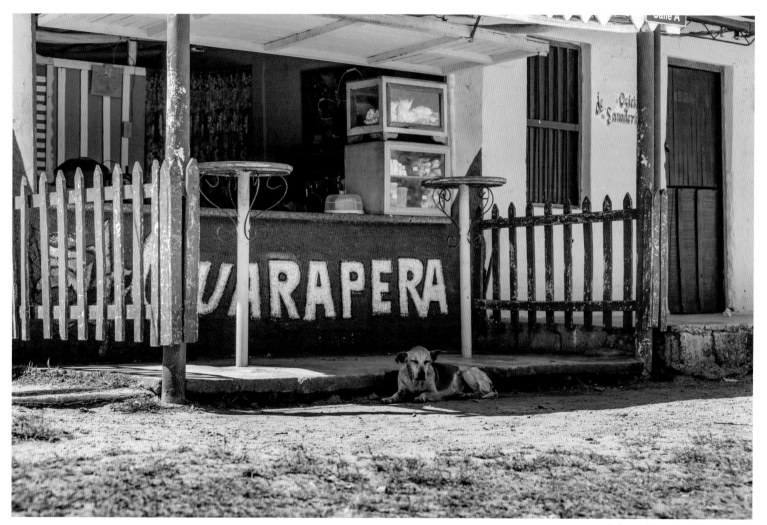

Briones Montoto, Pinar del Río

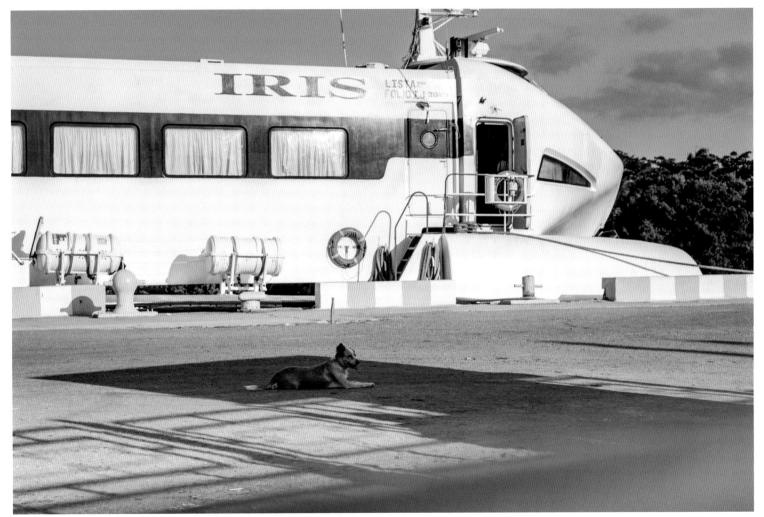

El Catamarán *Iris*, Nueva Gerona, Isla de la Juventud

Blanquita, Nueva Gerona, Isla de la Juventud

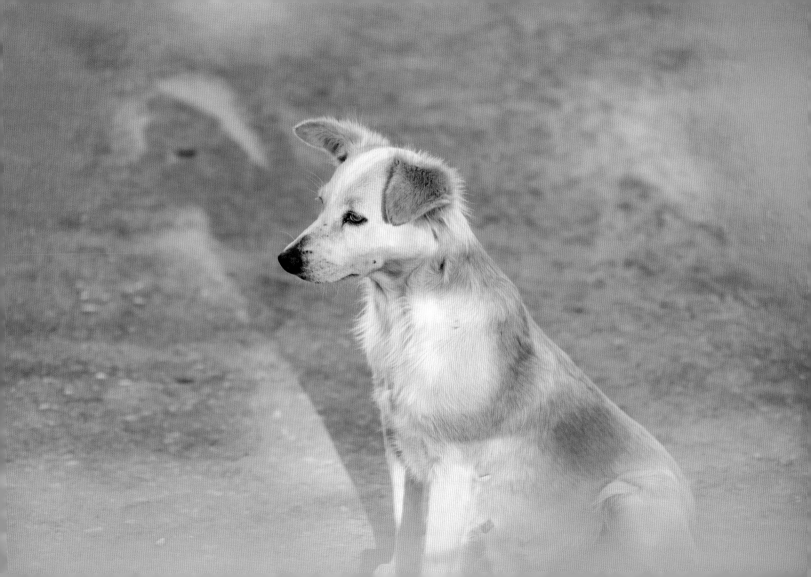

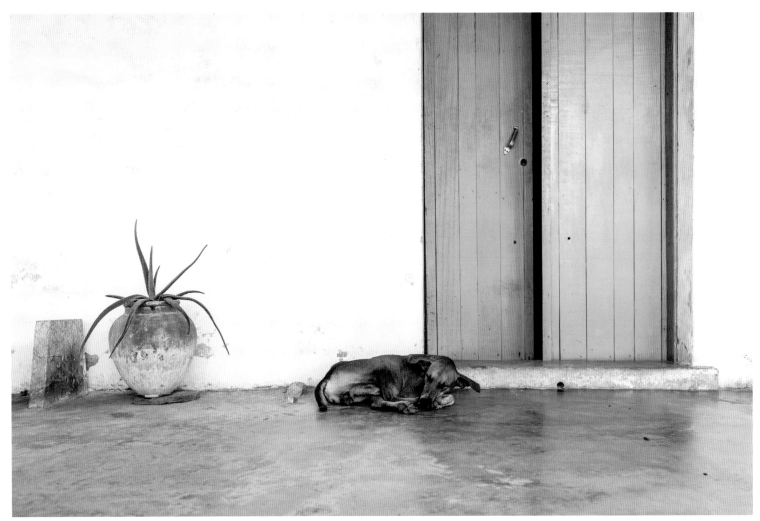

Finca El Abra, Isla de la Juventud

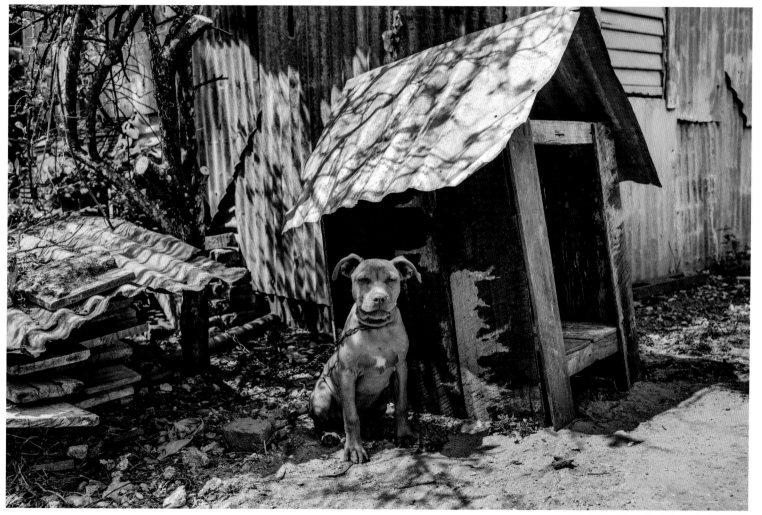

Saocan, La Fe, Isla de la Juventud

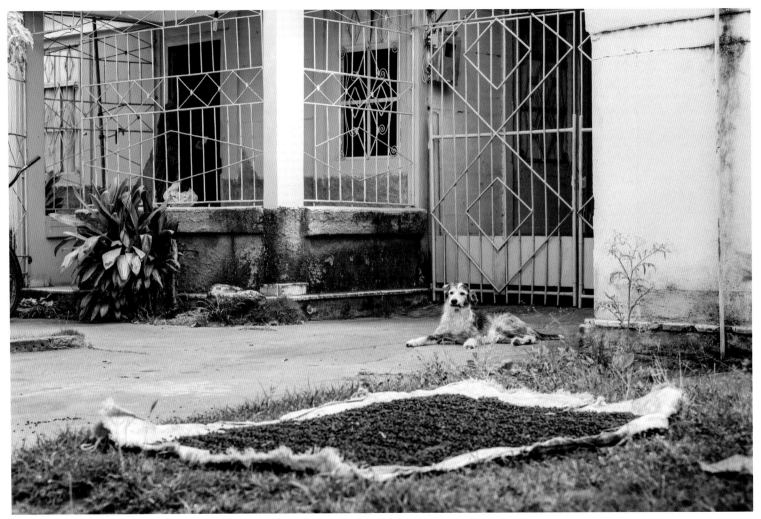

La Fe, Isla de la Juventud

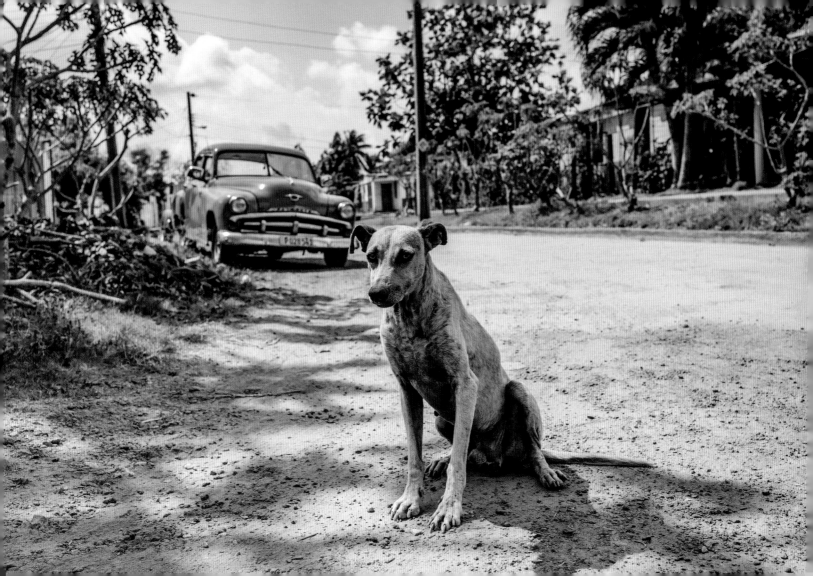

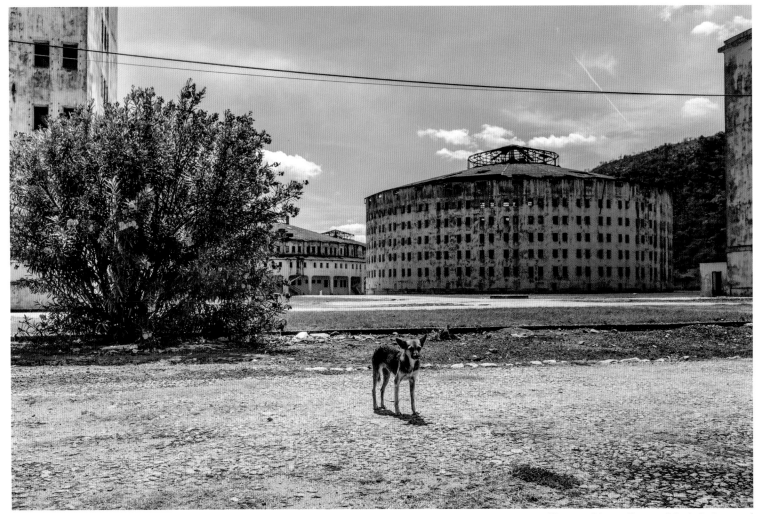

Presidio Modelo, Reparto Chancon, Nueva Gerona, Isla de la Juventud

Reparto Chancon, Nueva Gerona, Isla de la Juventud

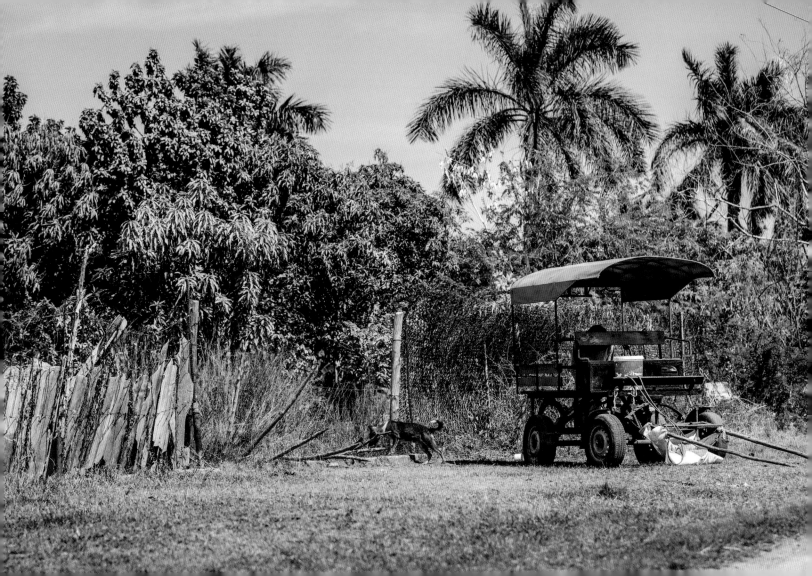

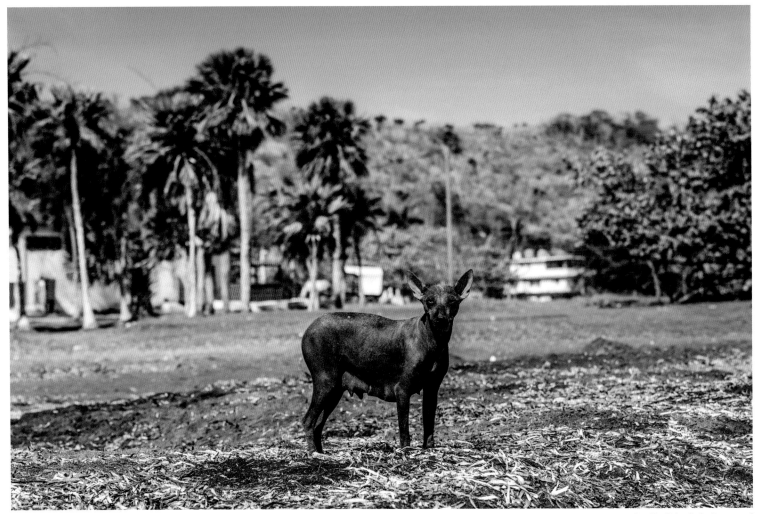

China, Playa Bibijagua, Isla de la Juventud

La Fe, Isla de la Juventud

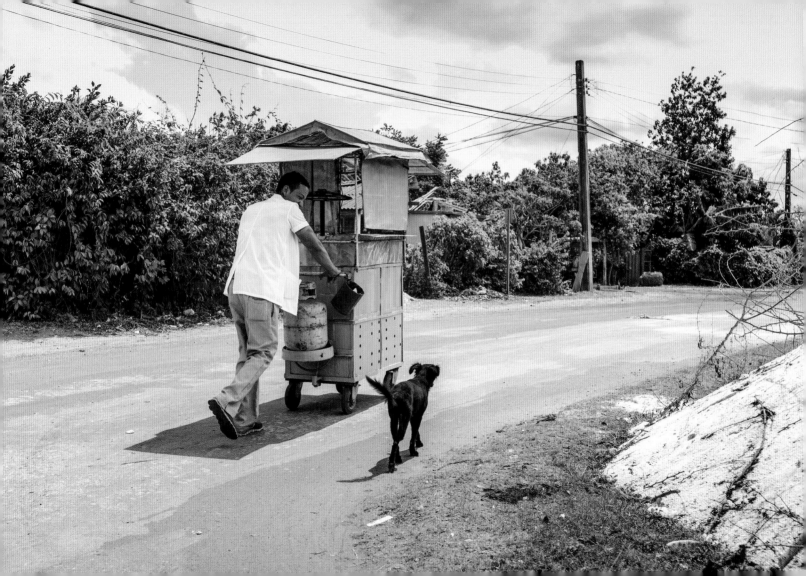

Edited by Kim Grandizio

Type set in Times New Roman
ISBN: 978-0-7643-5803-6

Printed in China

Published by Schiffer Publishing, Ltd.
4880 Lower Valley Road
Atglen, PA 19310
Phone: (610) 593-1777; Fax: (610) 593-2002
E-mail: Info@schifferbooks.com
Web: www.schifferbooks.com

For our complete selection of fine books on this and related subjects, please visit our website at www.schifferbooks.com. You may also write for a free catalog.

Schiffer Publishing's titles are available at special discounts for bulk purchases for sales promotions or premiums. Special editions, including personalized covers, corporate imprints, and excerpts, can be created in large quantities for special needs. For more information, contact the publisher.

We are always looking for people to write books on new and related subjects. If you have an idea for a book, please contact us at proposals@schifferbooks.com.